T WE
KEEP

150 PEOPLE SHARE THE ONE OBJECT THAT BRINGS
THEM JOY, MAGIC, AND MEANING

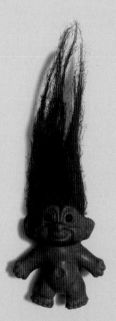

BILL SHAPIRO with **NAOMI WAX**

RUNNING PRESS
PHILADELPHIA

Running Press
Hachette Book Group
1290 Avenue of the Americas
New York, NY 10104
www.runningpress.com
@Running_Press

Printed in China

First Edition: September 2018

Published by Running Press, an imprint of Perseus Books, LLC,
a subsidiary of Hachette Book Group, Inc. The Running Press
name and logo is a trademark of the Hachette Book Group.

The Hachette Speakers Bureau provides a wide
range of authors for speaking events. To find out
more, go to www.hachettespeakersbureau.com
or call (866) 376-6591.

The publisher is not responsible for websites (or their content)
that are not owned by the publisher.

Print book cover design by Richard Baker and Susan Van Horn
Print book interior design by Richard Baker
Photography credits appear on page 207
Portion of cover photo © Getty Images
Page 132 illustration: © 2018 MARVEL

Library of Congress Control Number: 2018933852

ISBNs: 978-0-7624-6254-4 (hardcover), 978-0-7624-6255-1 (ebook)

1010

10 9 8 7 6 5 4 3 2 1

LET'S START HERE

IN THIS BOOK, you will find the story of a bottle opener that a drug-dealing grandmother gave to her grandson. The strange pincushion that foreshadowed a future writer's wanderings. The bullet a soldier would have used to kill himself had his mission gone south. The notebook sketch that sparked a hit movie.

What you won't find is the story of the locket that, in small and subtle ways, led to the idea for the book itself.

Naomi and I were poking around a yard sale in rural New York when, next to a Vietnam-era Zippo, she spotted a locket. Inside, the inscription read, "My Love Forever" in letters now faded by time. There was a date, too: 1911. The locket was so delicate, so beautiful, so personal that it was hard to fathom how it had ended up here, at the end of some driveway, for sale to strangers. Maybe it had belonged to the homeowner's wife who'd run away with her lover! Maybe it had turned up under a loose floorboard, like in a scene from a cheesy movie. More likely, the locket had simply been passed down so many times that the connection to its original owner had been lost.

page 14

I spoke with the young woman running the sale; she didn't have a clue about the locket's history. (The home belonged to her aging uncle, who'd relocated to Texas.) We left the locket for someone else, but walked away kind of fixated on how once an object is separated from its story, its importance begins to fade. We thought about the objects that take on meaning in people's lives, those treasures, trophies, and keepsakes we display on our shelves, stash in our drawers, tuck into our pockets, that move with us from home to home, that provide us with comfort simply because we know they're there. And we became intrigued by the stories that get wrapped tightly, if temporarily, around them.

EXPLORING OUR ATTACHMENTS to objects isn't exactly a new line of inquiry. Neanderthals, no doubt, sat around this mind-blowing thing called "fire" and asked each other what they'd drag away should the cave alight. And yet, today, as every turn of season seems to bring biblically destructive hurricanes, floods, and, yes, fires, more and more of us find ourselves facing the no-longer-theoretical question—"what would *I* take?"—in real time and with real consequences. Those of us spared from each new disaster quietly give thanks, but do so with a growing sense that as our climate changes, we, too, may have to choose, grab, and go.

Of course it's not just our climate that's changing. The drive to have less stuff is clearly in the Zeitgeist: Our books, music, and photographs have moved from our shelves to the cloud, and the "sharing economy" encourages us to borrow rather than own; at the same time, we're seeing a cultural shift toward valuing experiences over things. And with the Tiny House movement nudging Americans to trade in that McMansion for 400 clutter-free square feet, it's not surprising that Marie Kondo has sold more than five million books urging us to rid ourselves of those possessions that fail to "spark joy."

page 42

page **54**

AGAINST THIS BACKDROP, Naomi and I began looking more closely at the objects in our own lives. Why had she held on to a pair of shredded blue jeans that she first wore in high school? Why did I still have a hand-scrawled hitchhiking sign from a trip through Germany 30 years ago? As we shared the stories behind these objects and the meaning they held for us, aspects of our lives emerged that we'd never talked about with each other—or even really articulated to ourselves. *That* seemed interesting.

And so we began asking our friends about the objects they've kept, then friends of friends—and then we cast a wider net. Our research took us on a poky, 1,600-mile road trip through the Great Plains states where we lingered in one-stoplight towns with names like Elk Horn, Dell Rapids, and Ida Grove. We talked with folks in the coffee shops, meat lockers, and mayor's offices where they worked, and heard stories about objects carried across the Rockies in a covered wagon; brought back from Novosibirsk, Siberia; pawned and later repurchased.

In the end, we interviewed people from all over the country, in red states and blue, some well-known and some who wished to remain anonymous, one percenters and those with (almost) nothing. This book is a compendium of their treasured possessions and the often untold histories behind them.

One thing in particular that struck us: Of the more than 300 people we spoke with, not one chose an object because of its dollar value. Our hearts are not accountants; we cling to the meaningful, not the monetary. What makes these objects so evocative for us is that they hold the memories of people, of relationships, of places and moments and milestones that speak to our own identity. Sometimes they connect us to a time in our life when we realized all that we were capable of. Sometimes they connect us to the best we've seen in others and to what we aspire to be—and beyond that, as the Grateful Dead's longtime publicist put it in my conversation with him, to our place in "the ongoing pageant of human drama." What Naomi and I came to see is that these bottle openers and bullets, these playing cards, letters, and lockets not only crystallize core truths about each of us but also help us tell the stories of our life, even explain our life to ourselves. And for that reason, they're priceless.

P.S.: GRANDPA'S AX? An old charm bracelet? A Christmas ornament, magic wand, or a hubcap? If you have a treasured object, we'd love to hear about it. We're still talking to people, still collecting unique stories. You can share yours—or read more—on our Facebook page (facebook.com/groups/WhatWeKeep/) and on Instagram at (=WhatWeKeep).

page **17**

ONE MORE NOTE: The stories in this book are the result of casual conversations as well as more formal interviews, and we've edited them for length and clarity. Many of the objects that appear on these pages were photographed by the people who own them.

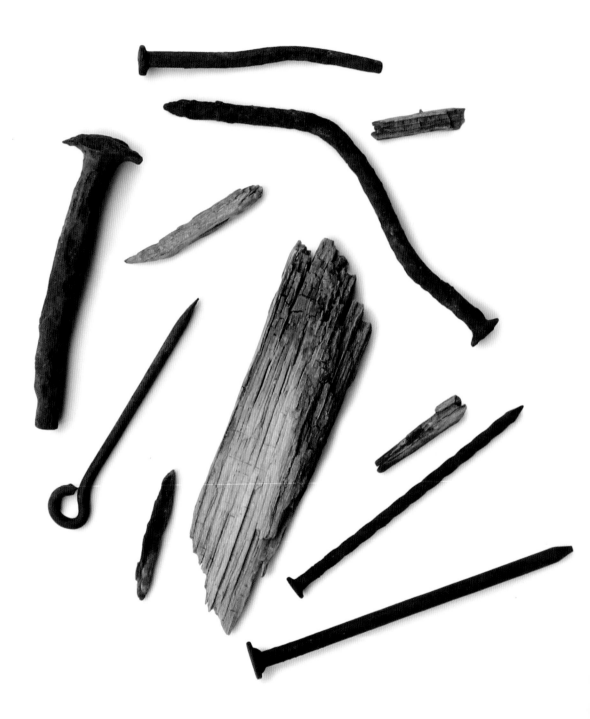

"I WANTED SOMETHING TO REMEMBER THE DAY BY."

I loved the day we spent searching for this old ghost town in New Mexico, in a little red car, just enjoying each other's company. He and I could spend days on end together and never run out of things to talk about. I'd never felt a connection like that with anyone.

When we finally found it, the old silver-mining town was completely abandoned, just falling-down buildings in the desert. We didn't take any photos, and I wanted something to remember the day by, just to, you know, bring a little piece of it home. So as we were walking and kicking up dust, I'd pick up an old bent nail or a piece of wood and put it in my pocket.

I think these nails and splinters mean more now that the relationship's over. Originally, they were about us exploring this really cool mining town. But the town is over, and so is our relationship, and I cherish these fragments, these fragments of a ghost town.

~ **Jackie Mock,** artist, New York, NY

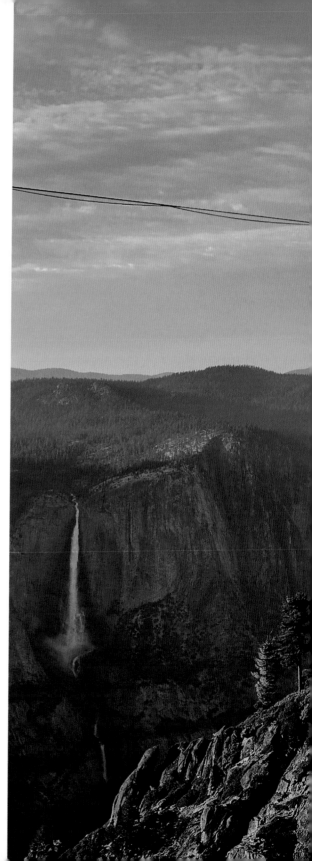

"IT HELPED ME COME ALIVE."

Before I tried the slackline, I didn't have a passion. I was going through the motions. I didn't know what I wanted to do and felt like there was nothing *to* do. It was like, "Let's go to the bar tonight" or "What's on TV?" This flat, one-inch-wide piece of webbing opened up everything and helped me come alive.

I started in a park, a foot off the ground, and saw walking the line as a safe way to get over my fear of heights. At first, it was like the tiniest piece of rope under my foot, like walking on a rubber band. Then one day it switched, it felt familiar. When you're 4,000 or 5,000 feet in the air, in a space where you're not supposed to be, you have to focus on what's familiar. Now the feeling of the line calms me down.

Highlining changed my whole mind-set. It's brought me adventure, I've traveled the world, I started my own business, I met my fiancé—all because of this piece of rope.

~ **Kimberly Weglin,** highliner, Sacramento, CA

KIM WEGLIN, AT 3,500 FEET,
YOSEMITE NATIONAL PARK

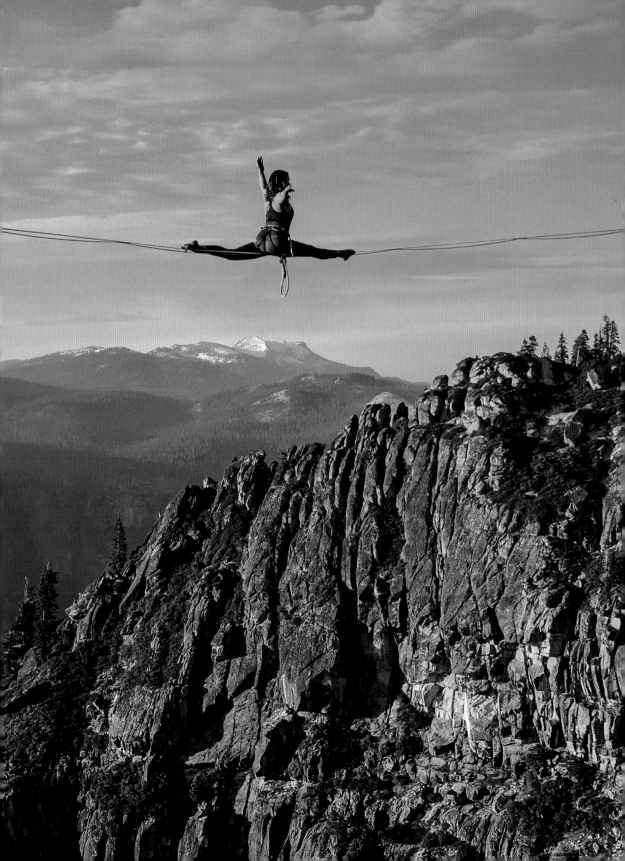

"IT'S THIS ABSOLUTE TANGIBLE REMINDER THAT MY LIFE WAS ONCE THAT WEIRD."

"My strat" sounds cooler than it is because it isn't a Stradivarius or Stratocaster. It's my straw hat—a boater, like they had in the '20s. We had to wear them at Winchester, my boarding school in England, along with a jacket and tie. We couldn't be bothered to say "straw hat." Just "strat."

We'd treat our strats like shit, and at some point the housemaster would say, "You're holding a piece of *straw*, and that won't do." I got a new one my senior year, which is the one I keep on the wall of my bedroom, where you'd hardly notice it.

I was 15 when my mom and stepdad, who were both teachers, left New York for a sabbatical in England. They didn't believe there were actual schools in California, where my dad lived; they thought everyone out there was making movies and fighting Indians. Winchester had the best academic rep in England—and I had no business being there.

My strat brings up the most delicious Dickensian memories: All of the classrooms at Winchester were stone, all the kids had fingerless gloves, and everyone's suits were shabby. But even sullen teenager me would look around and say, "This is the most beautiful place and these are the best teachers in the world."

There's some guilt at how much work I didn't do and how much I didn't live up to what I wanted to be there; a lot of the things I was going through didn't have acronyms yet, and if it wasn't English or history, I almost physically wasn't able to study. But the teachers were phenomenal, and although I was originally supposed to go back to New York after a year, I decided to stay. I stayed for the education . . . and then I abused it. I basically majored in dropping acid.

So while my strat really serves no purpose —it's not like I'm sporting it when I go bar-hopping—it's this absolute tangible reminder that my life was once that weird and that old-fashioned, that I lived through this crazy experience of being dropped into a hermetically sealed time capsule, a 600-year-old,

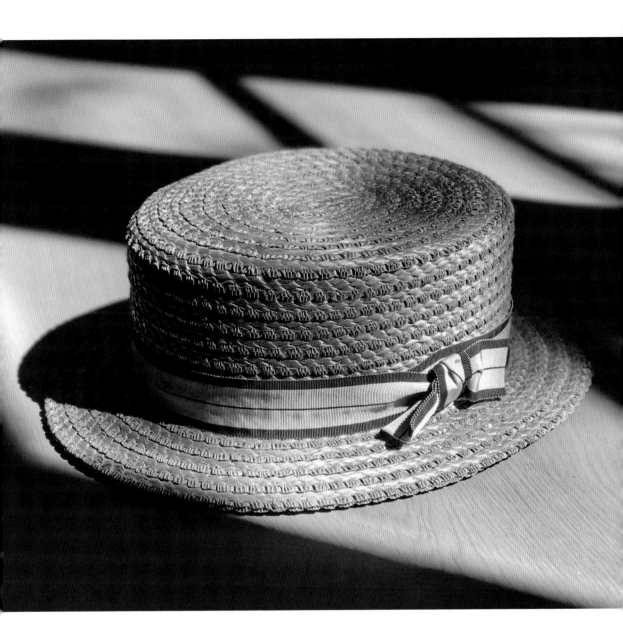

all-male boarding school in England.

There's a certain amount of pride—well, not exactly *pride*, more like *ownership*—and a little delight at having been part of something that shouldn't have existed in the modern era.

I'm not a collector of things. I've walked away from a lot and I have thrown away a lot, including a perfectly healthy relationship. So I'm real good at moving on. But the strat is different. There was never a time I didn't want my strat. There was never a moment when I was like, "I'm over this." I was at Winchester until I was 18, but, in a way, I never came back.

It does nicely on the wall.

~ **Joss Whedon,** writer, director, activist, creator of *Buffy the Vampire Slayer*, Los Angeles, CA

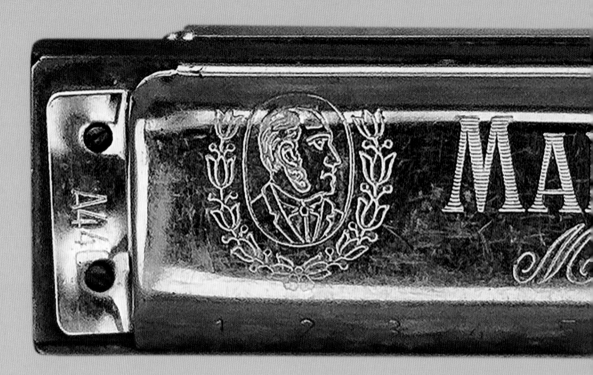

I met Kevin 40 years ago, when we were both working at the service station. We did gas, oil, air, windows, lube, everything. My wife and I had split up and his wife had left him, and every night after work we'd sit around for hours together drinking beers, Kevin playing guitar and me trying to figure out the harmonica. We'd tell stories about our relationships and our lives, and it filled an emptiness we both probably had at the time.

My first harmonica was a C harp, but there's

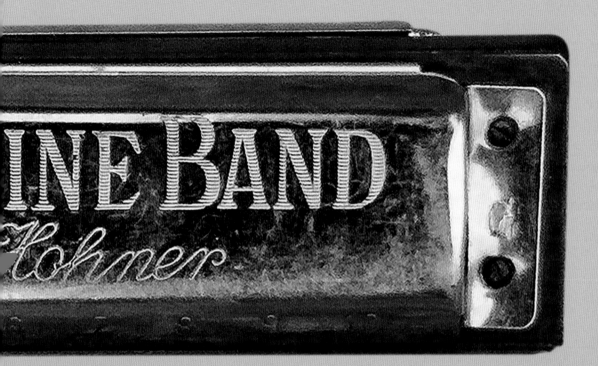

"It filled an emptiness we both probably had at the time."

this Marshall Tucker song Kevin always played, "In My Own Way," and it's in the key of G, so I bought this Hohner Marine Band G harp. That's the song that kinda got me started. Back then, Kevin used to say he hoped we'd have a friendship that when we were a hundred we'd be going to the coffee shop on Saturday mornings. We don't go to the coffee shop, but I'm 60 and we still get together three, four nights a week.

~ **Dan Pruitt,** radiologic technologist, men's prison; Archer City, TX

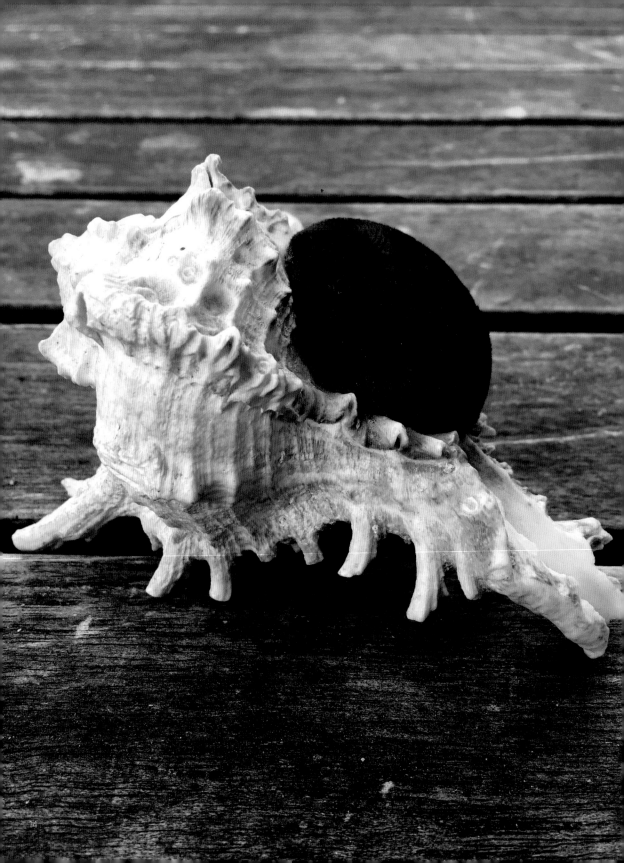

"THE SHAME ABOUT BEING POOR GOES ALL THE WAY BACK, AND HAVING A GLORIOUS SHELL WAS THE OPPOSITE OF THAT."

This has always been an object of wonder for me, but I've never talked to anyone about it. Even my husband didn't know the story—and we've been together 20 years.

The first week of first or second grade, we were asked to bring something in for show-and-tell. I walked around our tiny apartment in Chaska, Minnesota—by then my parents had divorced, my mom was a single mom with three kids, we were poor—and we didn't have anything interesting or cool for show-and-tell.

I decided I'd bring this murex shell. It was given to my mom by her father, who was in the army in the Philippines in the '40s and '50s. It was spiny and glorious. It had an air of mystery. But there was one problem: I wanted to say that I'd found it on an exotic beach. That's what I wanted people to think. For my story to work, though, I would have to separate the poufy red velvet pincushion part—which was glued into the crevice—from the shell. I used a butter knife, and I can still see where I made some progress. My mother came upon me and told me I couldn't do that. She said, "You can take the shell—but as it is, like a pincushion." I remember thinking that that ruined everything. I wanted so badly for people to think I'd found this shell. I was in tears. I was obliterated. And I didn't bring it.

The shame about being poor goes all the way back, and having a glorious shell was the opposite of that. You know, there's what you remember now but also what you remember imagining then, and I remember that even then I had this image of myself as the kind of girl who would be walking on an exotic beach, who would find a magnificent shell like this. It was not only that I was there but that I *found* the shell. I wanted to be lucky. It was also about beauty, about the ambition to be venturing out in the world and in a far-off place. What I knew was that I wanted to be something that I wasn't, that I wanted people to see me as someone who I wasn't. I've come to realize that it wasn't that I wanted to *deceive* but that I wanted to *become*.

The shell pincushion now sits on a shelf in my bedroom. Looking at it, knowing I had those thoughts of who I wanted to be and what kind of life I wanted to live, and knowing that I've done it, is the most beautiful, the truest thing. It's the core of who I am. The shell is like this present: It holds in its very being both the girl I was and the woman I became.

~ Cheryl Strayed, author, *Wild* and *Tiny Beautiful Things*; co-host, *Dear Sugars* podcast; Portland, OR

I'm not attached to many objects, but on my bookcase is a small cup where I store my treasures. It has one of Jerry Garcia's guitar picks, three acorns from exactly where Thoreau's cabin was at Walden, a chunk of the Berlin Wall, a slug from a Civil War–era rifle, and a little stuffed bunny my daughter bought me. And then I have a Greek drachma from approximately 300 BC with the face of Alexander the Great on it.

I think it was in 1996, not long after Jerry died, that I went to London to supervise *The Illustrated Trip*, an encyclopedia of the Grateful Dead. My wife and I were at the British Museum and had plans to meet some friends, and I was aware we had to get going. But when we walked out of the museum, there was a coin store right across the street. I said, "Come on," and we raced in. I walked up to the guy and said, "I want something really old." He put this drachma in front of me—smaller than a penny, slightly bent out of shape, the profile of Alexander on one side. I took one look and I said, "That's it."

I happen to be a Buddhist, and one thing you can associate with Buddhists is the idea that "this too shall pass, all things change, all things go away." And yet this coin has endured. It has no value in the conventional sense—it cost maybe $30—but it connects me to the ongoing pageant of human drama, to the human story of life, to someone who had it in their pocket 2,300 years ago. Someone—maybe many people—wanted this coin very much, sweated over it, maybe died for it. It makes me feel human to touch it. Hey, what is life if not the things that make you sentimental?

~ **Dennis McNally,** cultural historian, the Grateful Dead's publicist for 23 years, Jack Kerouac's biographer, San Francisco, CA

"IT MAKES ME FEEL HUMAN TO TOUCH IT."

"The diamonds are a reminder of how indestructible the soul can be."

Most military men don't wear their wedding ring when they're deployed. It can get caught in machinery or their weapon, and the reflection can attract enemies. But I knew that Michael would never take his ring off. I knew what it meant to him.

We'd only been married a year and a half when he was killed in Iraq. The Casualty Assistance Office told me that he was wearing his ring, that they were going to send it back to me in a manila envelope. But I wanted Michael to be able to wear it to Dover and, eventually, be cremated with it on.

After his death, there were so many dark moments that I never thought I'd come out of. It was like I was falling down a hole, and it took me a long time to remember who I was. My ring has been a part of my journey: I didn't take it off for seven years. I was only 19 when we got married, and the ring symbolized the love Michael and I had for each other, love in its purest form, undiluted by time. But then three years ago, I put the diamonds from the ring onto this necklace. It's come to symbolize coming out of my darkness. The diamonds are a reminder of just how indestructible the soul can be, and that I didn't give up, that I made it through.

~ **Taryn Guerrero Davis,** founder, American Widow Project; Wimberley, TX

"I HAD A MONSTER UNDER MY BED, AND GIZMO PROTECTED ME FROM HIM."

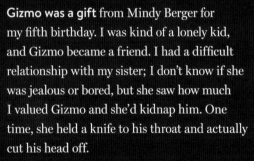

Gizmo was a gift from Mindy Berger for my fifth birthday. I was kind of a lonely kid, and Gizmo became a friend. I had a difficult relationship with my sister; I don't know if she was jealous or bored, but she saw how much I valued Gizmo and she'd kidnap him. One time, she held a knife to his throat and actually cut his head off.

I had a monster under my bed, and Gizmo protected me from him. But at some point, the monster started to try to get Gizmo; I would hide Gizmo behind my back and the monster would say, "I'm going to stay here and wait for Gizmo." While he waited, we'd have a conversation. Eventually the monster became my friend, too.

Today, I keep Gizmo on my dresser. He reminds me of that little, scared girl that needed a friend, and of that era when I believed Gizmo might have some talismanic powers to protect me. Part of me is still that scared girl—it's hard to be a woman in science, it's hard to invent knowledge—and having Gizmo here, on the dresser . . . I guess there's comfort in that continuity.

~ **Jillian Wormington,** vector-borne disease researcher, Texas A&M University, College Station, TX

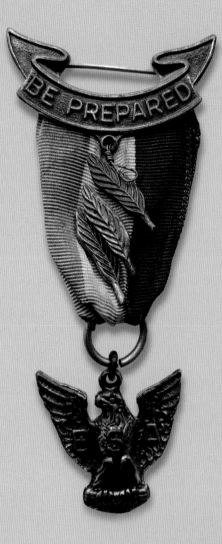

Only a tiny percentage of Boy Scouts make Eagle Scout, and a lot of those people lose their medals in time. I was 15 and 11 months when I received this, the youngest Eagle Scout in my troop in Clifton, New Jersey. I keep it in my bedroom in a prominent place on a bookshelf across from my bed.

The "Be Prepared" motto has guided me in everything. I've even saved a couple of lives. I rescued a woman from her car after she skidded on an icy highway; I helped father-and-son kayakers who were stuck in roaring rapids and petrified; I pulled my wife from a cold, fast-moving river. I see a direct line from this badge to those actions: the idea of staying calm in moments like that and having the mind-set of being able to say, "I can do this." Being in scouting profoundly and forever changed me. To me, it's what WWII was to the guys who fought there. That was the most amazing period in their lives, that was their moment. This was my moment.

~ **Peter Osborne,** historian, Red Cloud, NE

"BEING IN SCOUTING
FOREVER
CHANGED ME."

Rare honor: In the last 100 years, just 2.01 percent of eligible scouts qualified for the Eagle Scout award. Two who did? Steven Spielberg and Neil Armstrong.

"They're the ramblings of an
INSANE
MIND."

It's just a doodle in my journal, but it changed my life.

I got inspired to keep a journal when I moved to New York and saw Chris Rock and Colin Quinn and Louis C.K., guys I admire and respect, bringing these classic yellow pads onstage. Just yellow pads, like what you'd get from Staples or Office Depot. I remember talking to Colin, and he told me that this separation happens between comedians, and it comes down to who's gonna write the most. He said, "You just gotta write, you gotta vomit it out, what you're thinking and why—and keep asking yourself *why*." And so almost like when you join a gym as a New Year's resolution and say, "I gotta get in shape! I'm going to buy my new workout outfit!" I went out and got this really nice bound notebook.

In 2013, I made this doodle on a flight to India to visit family. When I look through the pages around the doodle I see some really, really shitty ideas. They're the ramblings of an insane mind, my most personal thoughts and feelings—scarier than your browser history because your browser history is just *what* you searched; this is *why* you searched. But then there's this drawing. I remember thinking,

What would the communion of a TED Talk *meets* The Moth *meets comedy look like? Could I shoot a comedy special this way . . . not just a superwide shot of me standing in front of a lot of people, but bringing the camera onstage? What are the shots that would look really cool?* And I started storyboarding the concept, drawing rectangles and then filling them in.

Eventually, this became *Homecoming King*, my Netflix special. It's wild to think that an amazing idea that changes your life can sit next to the dumbest idea ever—*What if Taco Bell combined pizza and a taco??!!!* The mountaintop and the valley right next to each other. That juxtaposition is very powerful to me, and that's what I love about the creative process. I never want to forget that. Looking at this doodle reminds me that if you're in the middle of a terrible idea, the next one could be great, and, likewise, if you have a great idea, that others will be terrible.

~ Hasan Minhaj, comedian, New York, NY

VFX:
Cracked
Glass that
SLOWLY
cracks over
time

← Shards of glass piqued onto the floor

Slow
dissolve
during
American Dream Tax

Marc, ~~what~~ what is our color pallate for Act II?

JIB/DOLLY

CLOSE UP FOR MONOLOGUES

23

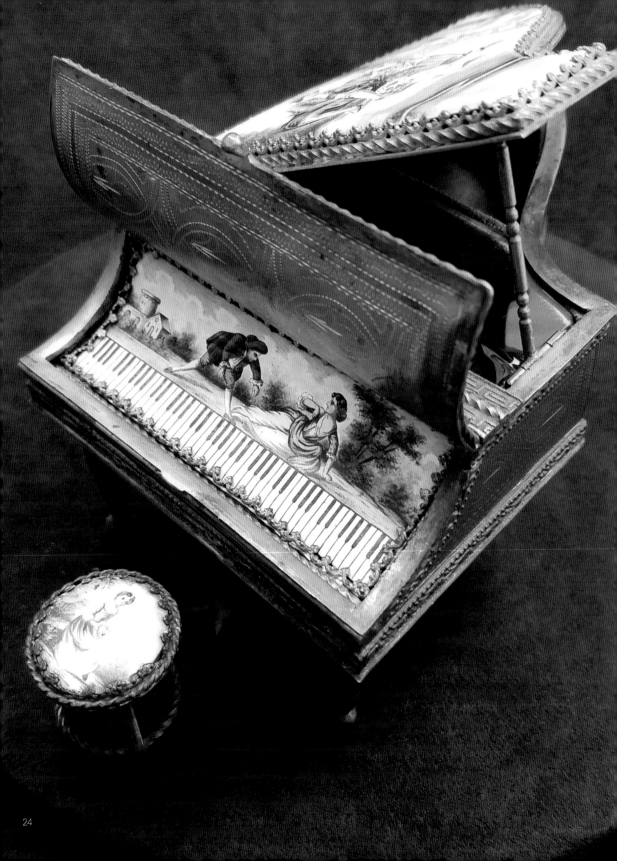

"To repair the world each day.
That's what I do."

I started working with music boxes in 1977, and since then I'd say tens of thousands have passed through my hands. But this was the first. It's a miniature piano from the 1940s or so, and it belonged to my grandparents. I never knew my grandfather and I haven't been able to identify the melody, but I like knowing we listened to the same music. The piano could use some restoration; there's a chip from where the housekeeper dropped it and the velveteen inside is worn—sort of like the plumber's house that needs to have the toilet fixed.

There are quite a few people who do restorations, but I focus on the mechanisms, and there are only maybe 8 or 10 people who do what I do. It's nice to be able to take something apart that's not functional and make it run smoothly. Like fixing an old car, tuning it up, making it sound great. There's a Jewish phrase, *tikkun olam*: "to repair the world each day." That's what I do. This is my little bit. And this is the one that started it all.

~ **Don Caine,** owner, Music Box Repair Center Unlimited, Lomita, CA

→ *Caine's mini baby grand stands 7 inches long and 3 inches high; it's made of brass with Austrian enamel.*

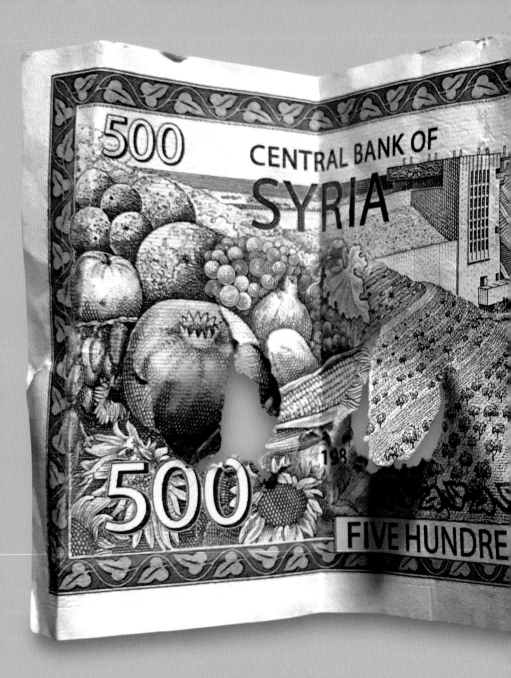

"The shrapnel went through my pants."

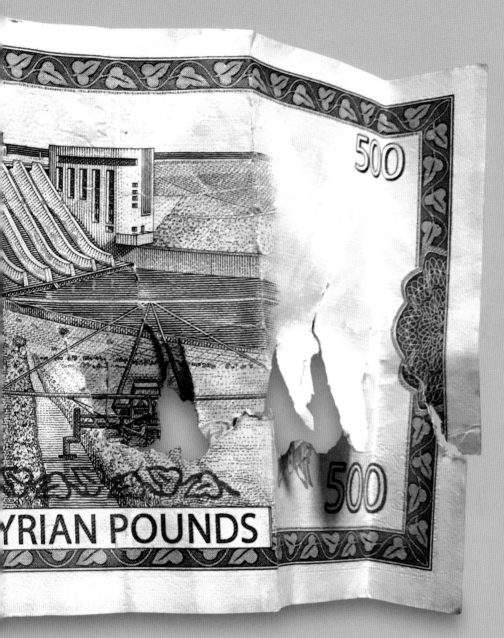

The hole in this banknote is from a piece of shrapnel. I was living in Dara'a, in southwestern Syria, when a bomb exploded near my house. The shrapnel went through my pants, through this banknote, and into my leg. Three years later, in the spring of 2016, I moved to the United States. The shrapnel is still in my leg, but the doctors tell me that if they remove it, I won't be able to walk. I keep this banknote, with the hole in it, to remind me of my homeland and of my family still in Syria.

~ **Manal Al Mfalani,** teacher, Clarkston, GA

My mom was pregnant at 16 and divorced by 20—her first divorce, anyway. We lived in a small town in Washington State and were very impoverished. All we had were the bare necessities, nothing that was worth anything. But it was like that for my whole family going all the way back. My grandfather was the youngest of 13 kids, all of them loggers. You just think about how hard it was to stay alive back then; everyone died at 60.

I wear my great-grandmother's locket. The inscription reads, "To Victoria, from Thomas, December 25, 1919," which is the year their daughter—my grandmother—was born. It's amazing to think that a hundred years later, I'm in New York City with a penthouse office overlooking Park Avenue. For them to imagine they'd have a great-granddaughter doing something like this . . .

The locket connects me to my great-grandmother and to my past, but it also reminds me how much change is possible.

~ Jennifer Justice, president of corporate development, Superfly, New York, NY

My grandmother was 18 years old when she boarded a train and escaped Austria. As she was leaving, her mother gave her this locket. It was 1938 and it was the last time they saw each other; her mother was sent to a death camp in Belarus. This was her engagement locket. When I was six or seven, my grandmother gave the locket to me. I wanted desperately to open it, but the hinges were frail and she told me I should open it only once a year. I've only shown the inside to my husband and my best friend.

~ **Heidi Leyton,** founder, Tour Guides Berlin, Germany, and New York, NY

"LARGE POODLES AND QUITE
A BIT OF VODKA"

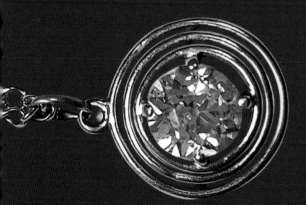

After my grandfather died, my granny took that sadness and climbed into an RV. With her best friend, her friend's husband, their large poodles, and quite a bit of vodka, they drove all around the entire country, visiting tourist attractions and places she'd never been. She was fun, witty, courageous. If I'm having a tough day, I try to channel those attributes. This necklace was hers, and I wear it six days out of seven.

~ **Rebecca Rose,** wildland firefighter, U.S. Forest Service, Pocatello, ID

"I STILL PLAY WITH IT ONCE A WEEK

BEFORE I GO TO BED."

It's such a vivid memory. One night, I was restless and couldn't fall asleep. I was eight or eight and a half, and I went into my mom's room and was, like, "Mom, I can't sleep." My mom *really* wanted to go to bed, so she handed me this puzzle. I couldn't believe she was just *giving* it to me. I was, like, *Oh my god!* I remember her smile and that she looked at me with this loving gaze, like maybe she was about to laugh.

For weeks, I was obsessed with it. I brought it everywhere. It's metal and really old and when the pieces would catch, I'd ask Mom to fix it. She'd wiggle it and shake it and then the pieces would fall into place. When she died two years later, I rediscovered the puzzle. The pieces still got caught, and I had to wiggle them and shake them to make it work again. In a way, this puzzle showed me that my mom had given me the tools I needed to make my life work again. I still play with it once a week before I go to bed because that's when I first played it. Every time I put it back in its case, I put it back solved, and facing the same way, which is exactly the way I got it. It feels like some order.

~ **Soren,** high school student, Brooklyn, NY

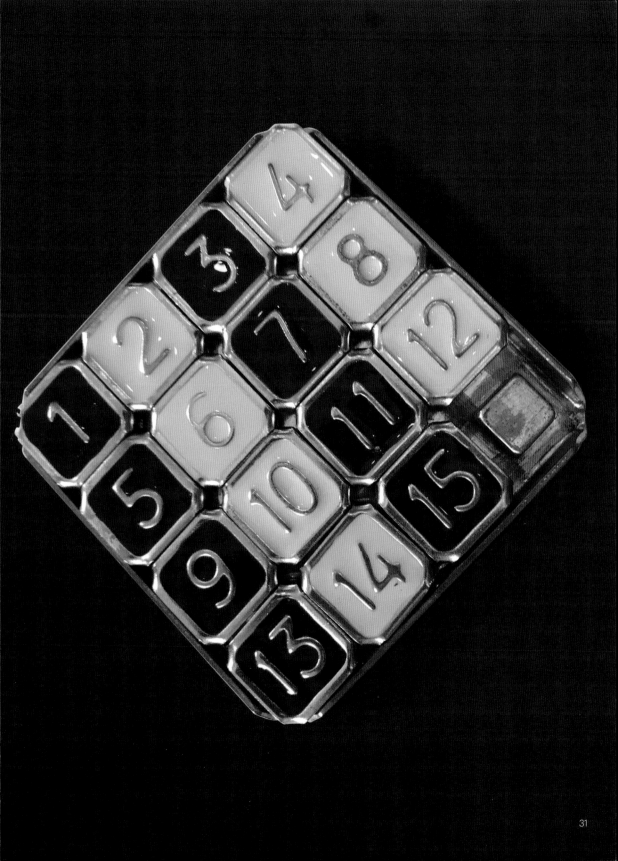

31

"I was forced to REINVENT MYSELF."

Romeo was given to me by a man looking to get rid of his roosters. He was beautiful and very feral, but it didn't take any time for me to tame him down. He'd come when he was called, he'd nap with me, he'd even talk in his sleep. I began to paint Romeo, mostly on brown paper bags. I'd never studied painting but Romeo inspired me.

My husband and I had a great antiques business for a while, but then the bottom fell out of the economy and we were dead broke. I was forced to reinvent myself. So I opened this little art studio. My paintings of Romeo were all over the studio, and people began buying them. Now I teach classes and the studio has even won a few awards. Painting Romeo on paper bags inspired me to become an artist, and there's no doubt he led me to where I am today. This painting was one of the originals; this was the beginning. A rooster on a paper bag on cardboard. I'd never want to sell it.

~ **Molly Roberts,** owner, Molly Roberts Studio, Excelsior Springs, MO

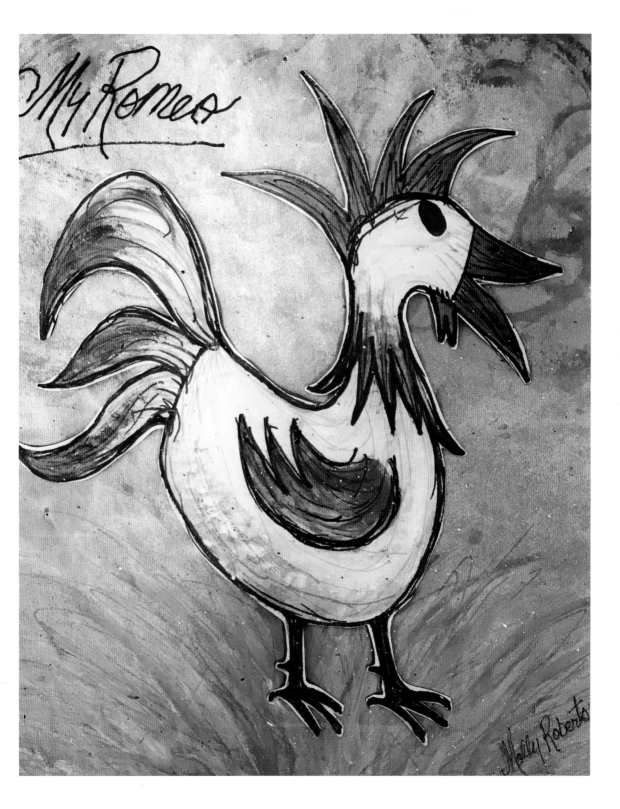

"THERE'S TRUTH
TO THE WAY YOU SEE THINGS."

Back in the '70s, they'd have five or six of these in the studios where they filmed TV shows. Someone in a booth would press a button and the box would light up, prompting the audience to laugh on cue. This particular box was used in the live taping of the pilot of *Diff'rent Strokes*, which my dad and his writing partner created. At that taping, my dad was in the booth pressing and pressing the "laugh" button. But no one laughed. My dad thought the show was dead in the water. After the taping, he grabbed one of the boxes and headed home.

But the show caught on. It started the career of Gary Coleman and became a cultural touchstone. *Everyone* knew *Diff'rent Strokes*. Forty years later, people still say, "Whatchu talkin' 'bout, Willis?" Of course, it also hurt a couple of the child actors.

I've kept this for the reason my dad kept it: to remind myself that if you think something is funny or truthful or beautiful or sad, it is. That's the truth. You don't need to prompt people to confirm what you think. There's truth to the way you see things.

When I get home from work at night, I flip it on. It turns the living room a deep orange.

~ **Barnaby Harris,** president, itsasickness productions, New York, NY

35

"BLUE HAIR, RED HAIR, GREEN HAIR"

I had 26 of these when I was a kid. Big collection. Trolls with blue hair, red hair, green hair, orange hair. One day I came home from spending a week at my dad's house and my mom had "cleaned" my room. She threw out all kinds of stuff that I loved. It was just *gone*. I bought this troll the next day. That's when I first realized I could defy her.

~ **Anonymous,** nurse practitioner, Alexandria, VA

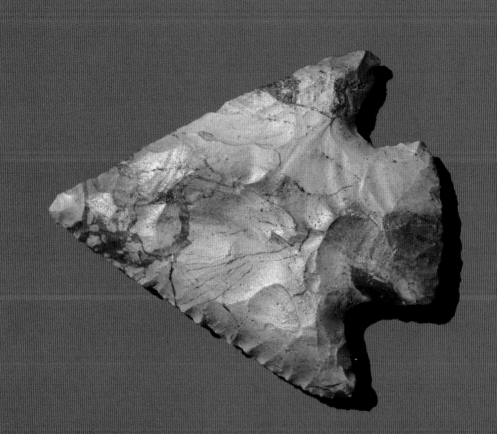

"YEAH, THAT'S MY THING.
THAT'S WHAT I WANT TO DO."

A group of us went down to Baja California in a van. We camped out on the beach, swimming, spearfishing, kayaking, just enjoying Baja. I'd been studying engineering for a couple years, but I needed to figure out what I really wanted to do. At one point, I was hiking through some nasty cholla cactus and I saw an arrowhead in the desert silt. I'd never found anything like this. The weight of it in your hand, the beautiful chips—it was like the person who made it went way out of their way to make it absolutely perfect.

It was during this trip that I'd look out on the water and see feeding frenzies, hundreds of dolphins in the water below and thousands of seabirds above—frigates, boobies, pelicans—all hunting for fish. I said to myself, "Yeah, that's my thing. *That's* what I want to do," and I never looked back. I transferred schools and got a PhD in ecology. That trip was a turning point for me, and while I don't have a lot of pictures, I have this arrowhead.

~ **James Gilardi,** executive director, World Parrot Trust, Davis, CA

"THIS IS
MY BABY.
I ALWAYS KEEP
IT CLOSE TO ME."

I live on the riverfront. I've been here for five years, and I ain't goin' nowhere until the good Lord take me away or a hurricane blows my bench away. Lotta people say, "Why would you want to live like this?" It ain't because anybody put me here. I put myself here. And I accept it. That's the point. I am content in it. I wouldn't trade it for the world, and that's no lie.

The day I found this rock was August 17, 2013, lying next to me when I woke up. How can I put it? It's like my Rock of Gibraltar, it's the backbone, my foundation. The way the stars connect to the galaxies, the way one star connects to another. I'm trying to tell you, this rock connects one life to another, one human being to another. It's connection to pain, to salvation, inner peace, love, and understanding.

This is my baby. I always keep it close to me. At night sometimes, I take it out, look up at the stars, and I smile and I say, *You got this, you got this.* I put it on my chest and feel a sensation that you don't feel anywhere.

When I leave, somebody will find it, and if they look at it like I do, they'll have the same satisfaction, understanding, and appreciation in trying to deal with other people.

~ **Charles Horn,** homeless by choice, Sanford, FL

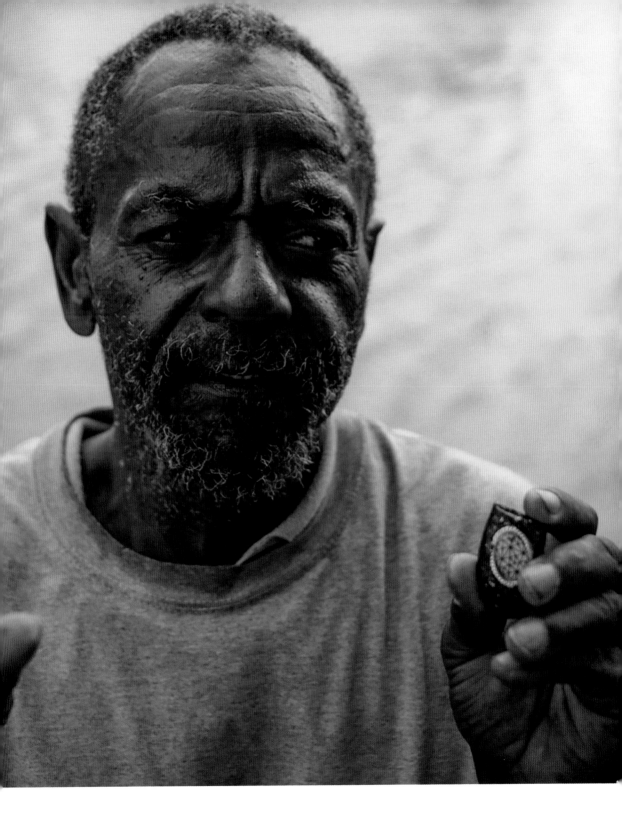

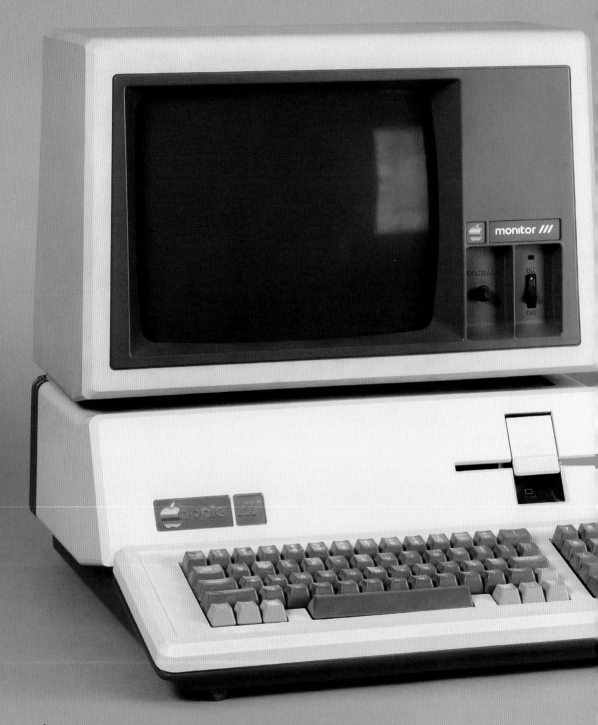

→ *"I even kept the manual," says Gates, "which, by the way, is still in mint condition."*

"I spent hours in my room
playing games and learning to code."

This Apple III was a gift from my father, who was an engineer working with NASA. I was about 16, and we were all supposed to share it, but I took it over almost immediately and persuaded my parents to let it live in my bedroom. I spent hours on it playing games and learning to code, and my dad more or less had to ask permission to use it. But he didn't seem to mind; he was always incredibly supportive of my interests in science and computers.

After I took a job at Microsoft, I had the Apple III sent to Seattle because it reminded me of how a computer changed my life. Our dream was to revolutionize the way billions of men and women lived and worked, and it was nice, as my career went along—I eventually oversaw Expedia and Encarta—to have a memento of my own journey.

There were a lot more women getting computer science degrees when the Apple III was released in 1980 than there are today. When I talk about the urgent need to help more girls see a future in technology, it's not just because I think it would be good for those girls—though I do. It's also because I think it would be better for society. Even now, as we run our foundation, the Apple III is a symbol of our conviction that innovation makes the future better for everyone—and we all benefit when there are more voices at the table making decisions.

It turns out that one of the single best predictors of whether a woman goes into a STEM field is whether or not her father believed in her when she was growing up. Well, my father did, in spades.

~ **Melinda Gates,** co-chair, Bill & Melinda Gates Foundation, Seattle, WA

"The water's coming in through the walls,

THROUGH EVERY CRACK."

We did okay through the first days of Hurricane Harvey, through the rain. We fought it. But then they released the reservoirs, and it took us a while to realize that this was really happening. We fought that night, too, but at one point it was over: It came in all at once, from all sides of the house. Outside, it was dead quiet. No rain. No cars. The power was out. There was no movement. But the water's coming in through the walls, through every crack.

That night I got a text from my son:
- *How are you doing?*
- *Fine.*
- *Are the Magic cards safe?*

Yes, the Magic cards were safe. They were the first things I'd grabbed from the office downstairs. My whole life was about to get flooded—there were photo albums, rugs, books down there—but I'd gathered the cards from the floor and brought them upstairs. It took four trips because there are 3,000 or 4,000 of them, in three-ring binders and 2-foot-long recipe boxes. My son was half-kidding—but only half. He wanted to know. Those cards are our connection.

I started playing Magic: The Gathering with a few guys in '95 when I was studying for my MBA and getting sober. We stopped playing after a few years, but I kept my cards, kept them through my first marriage, and when I got divorced I brought them with me. I remember thinking, "Maybe my son will be a little nerdy, too, and I'll get to share this with him." When he was young, he liked the pictures. But as he got older, he liked that each game had an infinite number of possibilities. Being a divorced dad, I saw Ethan every other weekend and I was looking for ways to connect with him. On Friday nights, we'd go to gaming shops with names like Asgard, and they'd have tournaments. We'd get clobbered but we didn't care—I was spending time with Ethan.

A lot of those cards they don't make anymore and they're worth quite a bit. But I keep them because my son likes them, because we have that connection.

~ **Nat Rosenthal,** consulting executive, Houston, TX

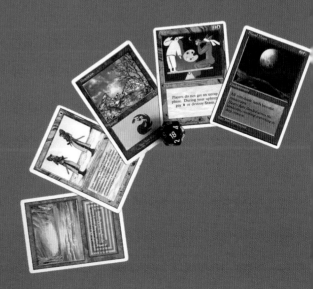

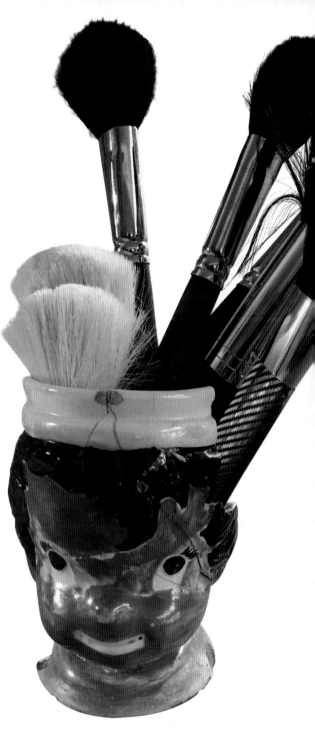

"That the cup
looked like me,
well, that was something."

We were living in New York in the late '50s and my mom started working with the Housing Department, helping out with after-school youth programs in the Bronx. One of the crafts projects she led had the kids making ceramic cups with faces on them. My mom brought one home for me. When you're a kid—and I was six or seven at the time—you get a little jealous when your parent is doing stuff with other children, so this was important to me. But there was something else: She had painted the face brown because I was brown, with a little curl in the middle of the forehead. That the cup looked like me—it was one of the earliest things I had with a brown face—well, that was something. It became my favorite cup, and evolved into my favorite pencil holder and, later, into my favorite holder for makeup brushes and pins. It's been on my dressing table for years. It's still there.

~ **Carla Hayden,** 14th Librarian of Congress, Washington, DC

➥ *At the Library of Congress, Hayden oversees 164 million items, taking up 838 million miles of bookshelves.*

"ALI'S GLOVE?

IT REPRESENTS A GREAT PART OF MY LIFE."

It's funny, I spent 12 years shooting covers for *Time* magazine, everyone from Charles Manson to the Pope, but the thing people think of when they think of me is Muhammad Ali—particularly the picture of Ali standing over Sonny Liston. It would be fair to say my career would not have gone the way it did if I hadn't been lucky enough to have Ali as my subject so often. I covered 35 of his fights and probably as many one-on-one sessions.

I grew up in low-income housing projects on the Lower East Side, and I became a fight fan because my father watched the *Friday Night Fights* on television. When I was young, I delivered sandwiches to the great photographers at the *Life* magazine photo studio, never dreaming that not that many years later I'd be posing the heavyweight champion of the world in that very studio.

Ali's glove? It represents a great part of my life. Being assigned to shoot a world heavy-weight title fight, getting the best seat in the house, having my pictures on the cover of *Sports Illustrated*, and getting paid for it? I used to pinch myself and think, *I should be paying them!* Listen, where I came from, you couldn't dream of such a thing. Ali was a career maker. That I would have the good luck to be assigned to shoot him as often as I did, that I would develop a friendship with this great fighter who became such a legend? Come on.

~ **Neil Leifer,** photographer and filmmaker, New York, NY

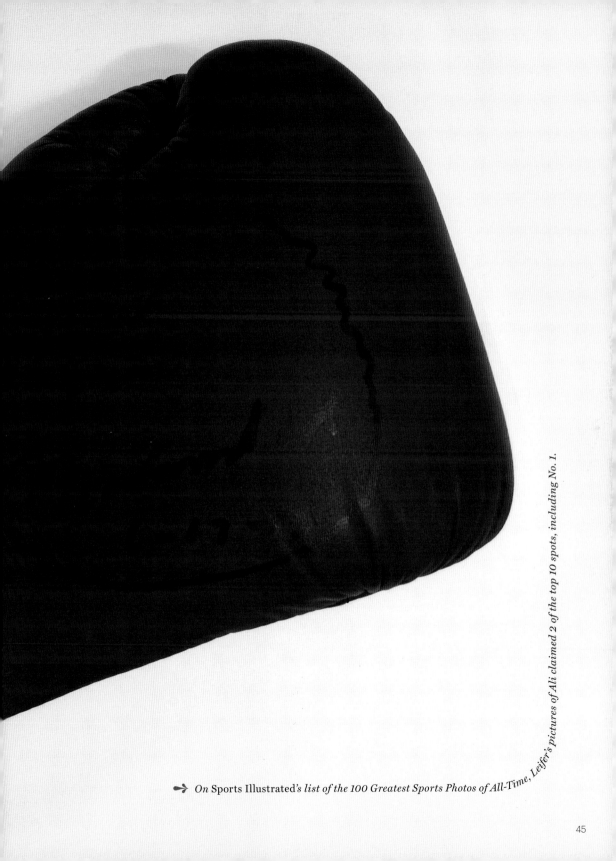

On Sports Illustrated's *list of the 100 Greatest Sports Photos of All-Time, Leifer's pictures of Ali claimed 2 of the top 10 spots, including No. 1.*

"I FEEL LIKE
I WAS BORN INTO IT."

I don't remember much of my childhood, but I remember this poster. It's always been in my life. I'll see these old photos of my grandmother, when my mom was a kid, not long after they emigrated from Laos, and this poster is in the background. It's the Hindi goddess of fertility and love, and my mom says she prayed to it when she was pregnant with me. In some ways, I feel like I was born into it, that it created a certain ethos at home and shaped who I became. It's like a physical reflection of who I am, everything I feel emotionally and spiritually. And to know that my mother and grandmother look at it the same way feels like some kind of déjà vu.

~ **Pavady Senechaleunsouk,** food truck operator, Fresno, CA

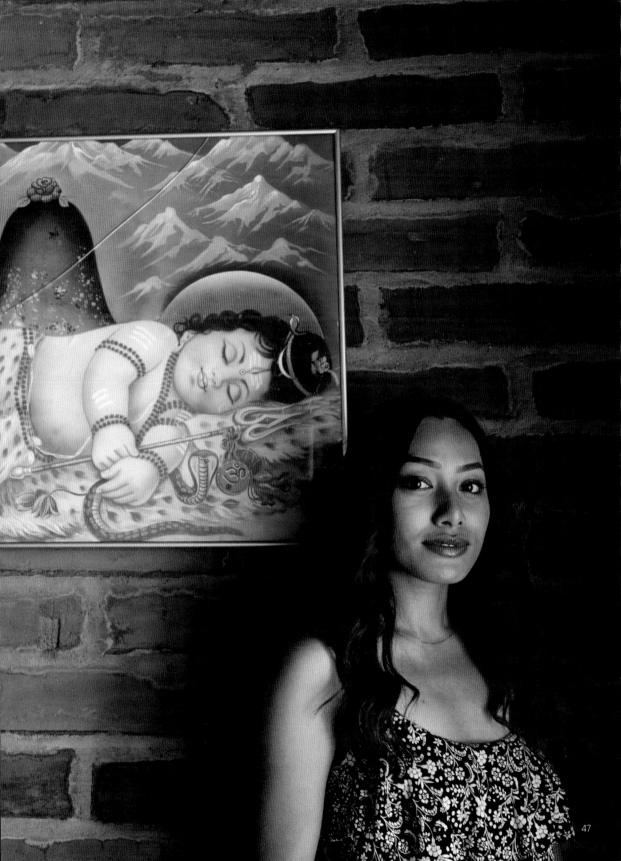

At its widest point, a bowling pin's circumference measures exactly the same as its height: 15 inches.

This I stole from a bowling alley on a drunken dare. It was stupid. I regret it. I used to go there all the time, but I never went back after I took it. I liked that place. For a while, I kept it like a trophy. Like, "Look what I got!" Now I keep it to remind myself what an idiot I can be.

~ **Dan,** sales associate, clothing store, Phoenix, AZ

"PROFESSIONALLY, SHE WAS A CPA.
BUT THAT WAS A COVER."

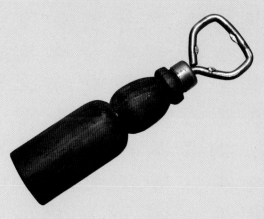

In one sense, it's the kind of unremarkable, run-of-the-mill bottle opener you might pick up at a garage sale. It was given to me by my grandmother, who . . . well, you might have thought she was unremarkable, too.

I called my grandmother Chicken Legs. She was small in stature and when I was really young, I saw her in a bathing suit and said, "You have chicken legs!" and that kinda stuck. What you need to know about her is that, professionally, she was a CPA. But that was a cover.

For 30 years, she was a drug dealer. She imported marijuana from Mexico in the '60s, '70s, and '80s, and my understanding is that she was the number-one importer. She was an individual who ate organic food, was business-smart, very focused, and kind of an amazing person. She lived in Northern California but she wasn't a hippie. She had a conservative look to her—no wild hair. Under the veneer of an old lady CPA, she ran a very large organization. And it was very much illegal.

We were close, and from a young age, I was able to decipher that something was highly illegal. But at the same time I could see that what she was doing wasn't bad. I saw happy, healthy, really appreciative people in her house; but I also saw people who were sick, people who needed help. She was positively affecting people's lives, and that's why she did it.

My grandmother gave the bottle opener to me at some point after she retired. Every time I use it I'm reminded of who she was and what she stood for. She really wanted to help people and she went against the grain to do it. This has guided me as a person. It's why I worked in a cardiovascular unit for 10 years, and it's why I started a nonprofit that introduces kids to mountain sports. My grandmother was a very simple person. She didn't have a lot of possessions; everything she had meant something to her.

~ **Anonymous,** founder, nonprofit organization, Boise, ID

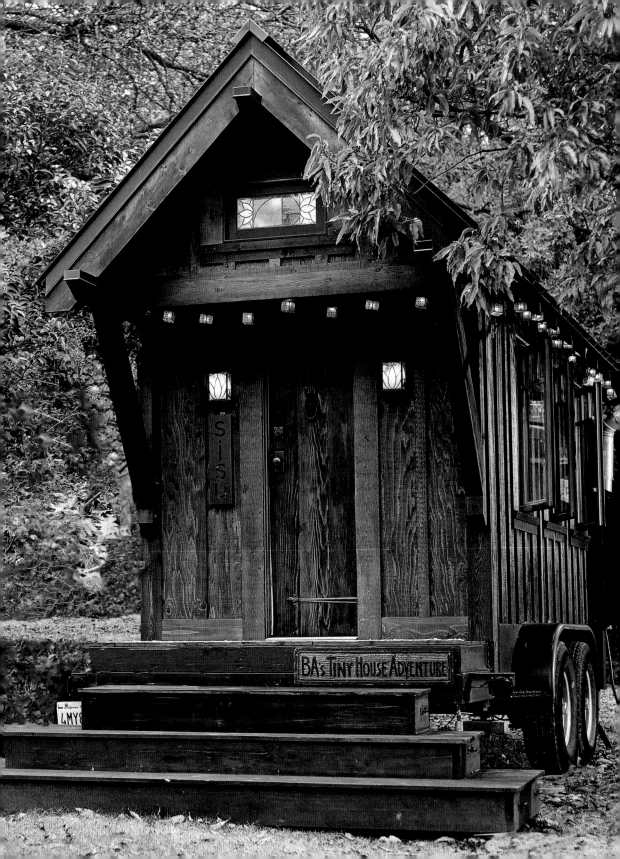

"When you **downsize** like this, you're surrounded by only the things you've loved."

For a single woman in Dallas to purchase a 1929 Tudor house was a big deal. I loved my house. I had a garden, a woodshop; I built a yoga deck in back. But after a while I felt trapped. I was a paralegal, but I found myself living paycheck to paycheck and in fear that the plumbing might go or the furnace would fail. Then, in 2012, my boss of 20 years told me he was retiring—and that I was being let go. About that time, a storm hit and shredded every house in the neighborhood, including mine.

I just threw in the towel.

I had a closetful of black suits, was trying multimillion-dollar cases, going to fancy parties—and I walked away. I realized I wasn't living the life I wanted to be living, that I was too dependent on others for my well-being. So I opened the doors to my house, enlisted my neighbors as cashiers, and put a price tag on everything. The only things I kept were my power tools and camping gear.

I'd always done what everyone expected of me, so this was out of character. But I was following my heart and it turned out to be the best thing I've ever done. Eighteen months after I sold my Tudor, I started building my tiny house. I had a lot of help—from friends, from the girls at Mentoring a Girl in Construction camp, from strangers who heard about my project and wanted to help. I never forget that this house inspired and empowered all of these people.

Often, when I pull up to my house, I'll take a moment and just say, *Holy cow, I built that with my own hands.* I mean, I sunk almost every nail. But it's become so much more than a house. My Tudor was 1,148 square feet, and now I'm living in 78 square feet. When you downsize like this, you're surrounded by only the things you've loved. You've gotten rid of everything that clutters your vision, so everything you see around you is what you've chosen and what you love dearly. And my tiny house, my *sanctuary*, holds all of that.

~ **B. A. Norrgard,** tiny house educator and advocate, Garland, TX

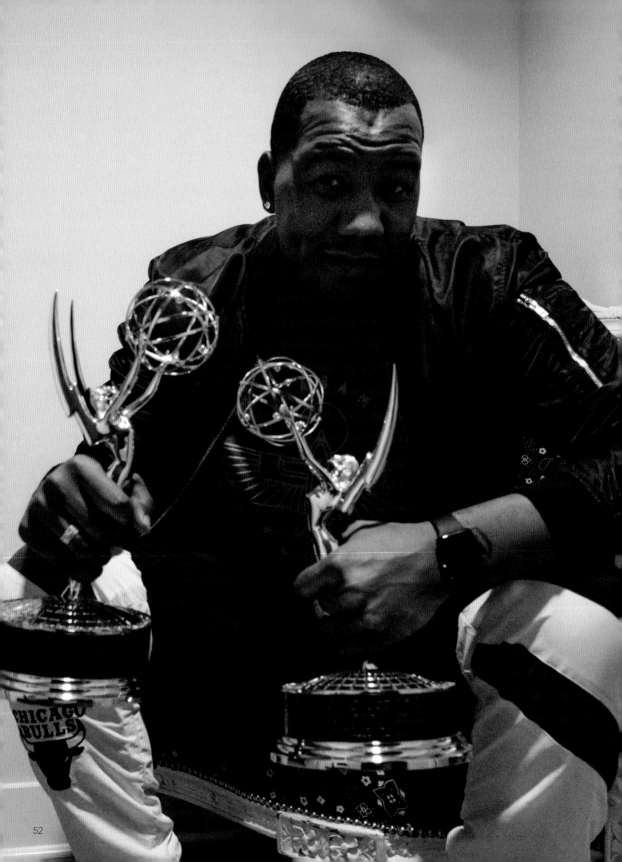

"Come on, man, don't rob the ice cream truck!"

To be born in Compton is to witness *everything.* Sometimes I'd come home and our house would be wrapped in police tape. The hamburger stand across the street was getting robbed weekly. The ice cream truck would get robbed, then wouldn't come back. *Come on, man, don't rob the ice cream truck!* I was walking down my block when I was eight or nine, and these guys drove by, pulled out assault rifles, and just mowed down a crowd right in front of me. I remember that like it happened five minutes ago.

Why these awards matter so much to me is that people where I come from don't win Emmys. They don't sit in a room writing political satire for Jon Stewart, and they don't stand on that stage. To have seen the things I've seen, to be that close to violence and murder, and then to hold a statue on that stage—with Viola Davis looking up at me—it's fucking crazy. It's a miracle.

Having these in my living room is a constant reminder to keep doing the work to bring more black and brown people, and more women, onto that stage. It was always about something bigger than winning. It was about giving a little hope to some kid from the inner city who wants to be a writer or director, about showing folks that there are a lot of people like me out there— that we're not one-offs, not anomalies.

~ **Travon Free,** comedian; head writer, *Full Frontal with Samantha Bee*; New York, NY

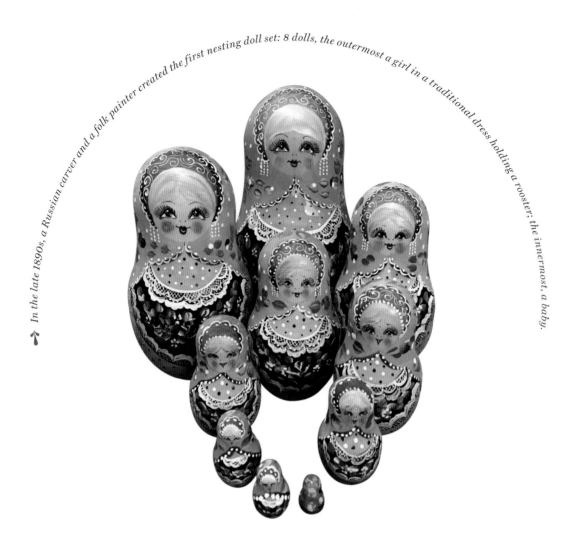

In the late 1890s, a Russian carver and a folk painter created the first nesting doll set: 8 dolls, the outermost a girl in a traditional dress holding a rooster; the innermost, a baby.

"THEY EMBODY HOW THINGS FIT TOGETHER FOR ME."

I purchased these nesting dolls on a street in Novosibirsk, Siberia. I was on a missionary trip just after I graduated high school, and that's where I realized my purpose. I was walking down the street and the people there were so beautiful that I suddenly realized that everybody, no matter where they are in this world, needs love—not in a Coca-Cola slogan kind of way. But I knew then that the grace that's been shown to me by Jesus was something I wanted to pass on to others, that I wanted them to feel loved and feel important and that they have a purpose. That's become my mission and passion. These dolls represent more than a time in my life; they embody how things fit together for me and a lot of my *why*.

~ **Renee Langvardt,** owner, Java Junkies café, Clay Center, KS

"I never felt CLOSER TO MY DAD than when we worked on that table."

My dad was a proud, blue-collar guy who worked in rural Kentucky coal mines all his life. He wasn't a hugger and he wasn't the kind of dad who was always taking me to ball games. He didn't care for my help with a lot of things because he was a perfectionist. He was a quiet fella, always in the middle of things.

I started doing woodworking projects with the 4-H. My mentor was a volunteer named Grady Osborne, who always had a short stub of cigar in his mouth and didn't have all the parts of his fingers. A classic woodworker. My dad was real handy, and he started coming to my sessions and giving me pointers. And my skills grew. At 11 years old, I became the junior woodworking champion of Hopkins County. My dad was proud of that.

When I was 12, Grady suggested I make this end table. We had furniture-quality mahogany with a lot of grain to it, and I cut all the parts. My dad was now engaged in this with me—he would sand some, then I would sand some. Grady had us put a coat of lacquer on it. Once it dried, he told us to take steel wool and scrub it off. We did that. Then he said to lacquer it again and we did that. Then he had us scrub it off. We did this five times. I don't

recall ever seeing another piece of furniture with a finish like that, and I had no trouble winning the championship again that year. I never before or after felt closer to my dad than those times when we worked on that table.

My father eventually experienced the ravages of Alzheimer's. His personality started changing dramatically and he lost his grasp of the current, trapped back in the day when my sister was a child and I didn't exist. For close to 10 years, I didn't have my real dad; that's a

cruel part of the disease. The table no longer looks like it once did—my sister restained it with walnut—and while I'm sad that it's not as glorious as when we made it, I'm free to use my imagination about how glorious it was. And it was glorious.

~ Ed Hancock, retired corporate executive; volunteer, Alzheimer's Association; Ocala, FL

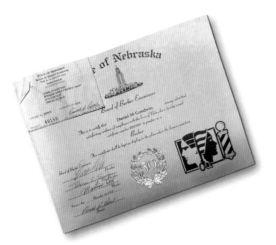

"YOU FIGHT SO MANY
BATTLES."

My younger brother joined the military at 15 by altering his birth certificate. When I saw that, I said, *I'm going in,* and I made a copy of mine and blurred the date. They looked at it and told me to come back when I was old enough. By the time they called me, I had forgotten all about it. I was 17 and that was June of 1949.

Then the Korean War started, and I was sent to the Philippines. I drove semis, worked mechanics, a little bit of everything. When I got back to Omaha, I was 21 and wanted to finish high school and—listen, I will not forget this—the superintendent, who was white, did everything he could to discourage me. He told me I had to pay $300 up front. That was a lie. He thought it would stop me; he thought I'd walk out of that meeting with my head down. No way. I went and I graduated. When I got out, I tried to get trucking jobs. All of them told me I was too young. *But I'd already been driving semis in the navy.* I wasn't too young; I was too black. This kind of crap happened all the time. You fight so many battles.

My older brother had a barbershop, so I decided to take advantage of that and I wound up going to barber school. That was November 1, 1953. I'll be honest, when I first started barber school, I was thinking about a different line of work. But pretty quick I started making a comfortable living, and I never looked back. After a year, I leased a shop, and then I bought this building. That was 50 years ago. With my makeup and my standards, I feel like I could have worked any job, but things being so unfair and so unequal, owning my own business turned out to be a very good thing. This certificate represents my livelihood, how I've taken care of my family, my independence. I didn't have to kowtow to anyone.

~ **Daniel Goodwin,** barber, Goodwin's Spencer Street Barbershop, Omaha, NE

"It was just right for double dating."

My family bought this Chevy truck new in 1948; I remember it was late summer because we chopped off corn with a corn knife and laid the stalks across the frame. I was 16 and it was just right for double-dating, stick shift and all. We had a family farm in Lu Verne, Iowa, but not many farmers had a truck at that time and it was certainly unique for a kid my age to use a truck. I remember we'd load the back with kids to go to the movies, and I went to my first football game in it. My wife and I have used this truck every single time we've moved. It's carried us everywhere, an old friend that holds a lot of memories.

~ **Wayne Marty,** retired biology professor, Le Mars, IA

Around the age of 15, I started getting up at 4:30 in the morning to read this bible. It's a Greek and Hebrew study bible, and I read it for an hour or two every day for two years. Its pages are stained with the grease of my hands and marked up with questions and notes—except for some of the more boring books, like Numbers and Leviticus. I have duct tape all

"MY RELATIONSHIP TO THIS BIBLE IS HELD IN

CONFLICT."

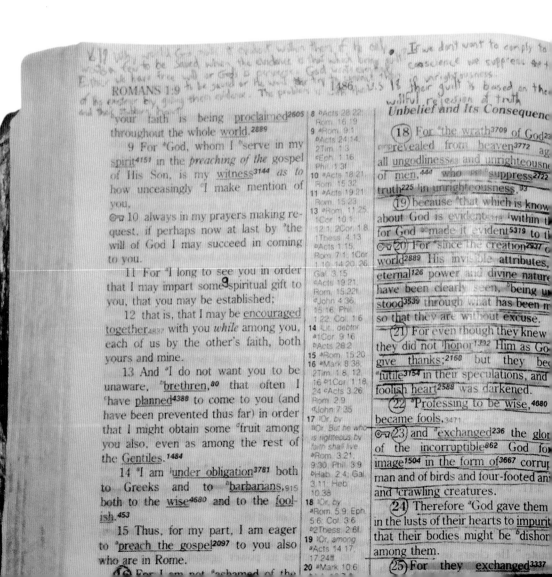

over it because the binding is ready to go.

My relationship to this bible is held in conflict. It represents a part of my life that I want to remember and helps me remember what I don't want to become. What started out as a time of having a lot of questions became a time of having a lot of answers. If you have a sacred book and it claims to contain the words of God,

it's easy to feel like *you* become the voice of God, and I think I treaded dangerously close to that.

It's on my shelf where I see it all the time, but I don't think I could ever use it again. I guess it's become symbolic for me, symbolic of the way time changes opinions, and that I can change for the good and for the better.

~ Caleb Wilde, funeral director, Parkesburg, PA

1487 ROMANS 2:14

r to ᵇdegrading₃₁₀ passions;³⁸⁰⁵ for ir women²³³⁸ exchanged³³³⁷ the natural function⁵⁵⁴⁰ for that which is unnatural,

27 and in the same way also the men abandoned the natural function of the man and burned in their desire³⁷¹⁵ toward one another, ᵉmen with men committing ᵍindecent acts and receiving in ʰtheir own persons the due penalty¹¹⁶³ of their error.

28 And just as they did not see ᵏfit to ᵏacknowledge¹⁹²² God any longer, ᵐGod gave them over to a depraved⁹⁶ mind,³⁵⁶³ to ᵖᵈᵒdo those things which are not proper,₂₅₂₀

29 being filled with all unrighteousness, wickedness,⁴¹⁸⁹ greed, evil;²⁵⁴⁹ full of envy, murder, strife,₂₀₅₄ deceit, malice;₂₅₅₀ they are ᵍgossips,₅₅₅₈

30 slanderers,₂₆₃₇ ʰhaters of God, insolent,₅₁₉₇ arrogant,₅₂₄₄ boastful,₂₁₃ inventors of evil, ᵏdisobedient⁵⁴⁵ to parents,

31 without understanding, untrustworthy,⁸⁰² ᵐunloving,⁷⁹⁴ unmerciful;⁴¹⁵

32 and, although they ᵒᵖᵗknow the ordinance¹³⁴⁵ of God, that those who ᵖpractice⁴²³⁸ such things are worthy ᵍᵒfdeath, they not only do the same, but also ᵇgive hearty approval to those who ᵖᵖpractice them.

4 Or do you think lightly of ᵃthe riches of His ᵇkindness⁵⁵⁴⁴ and ᶜforbearance⁴⁶³ and ᵈpatience,³¹¹⁵ not knowing⁵⁰ that the kindness⁵⁵⁴³ of God leads⁷¹ you to repentance?³³⁴¹

5 But ᵉbecause of your stubbornness⁴⁶⁴³ and unrepentant²⁷⁹ heart²⁵⁸⁸ you are storing up wrath¹⁷⁰⁹ for yourself in the day of wrath and revelation⁶⁰² of the righteous judgment¹³⁴¹ of God,

6 ᶠwho WILL RENDER TO EVERY MAN ACCORDING TO HIS DEEDS:²⁰⁴¹

7 to those who by ᵍperseverance in doing²⁰⁴¹ good¹⁸ seek for ʰglory and honor and ʰimmortality, ⁱeternal¹⁶⁶ life;²²²²

8 but to those who are ʲselfishly ambitious and ᵏdo not obey⁵⁴⁴ the truth,²²⁵ but obey³⁹⁸² unrighteousness,⁹³ wrath¹⁷⁰⁹ and indignation.²³⁷²

9 ˡThere will be ᵐtribulation²³⁴⁷ and distress⁴⁷³⁰ ⁿfor every soul⁵⁵⁹⁰ of man who ᵖᵖdoes evil,²⁵⁵⁶ of the Jew ᵒfirst and also of the Greek,

10 but ᵖglory¹³⁹¹ and honor₅₀₉₂ and peace⁷⁵¹⁵ to every man who ᵖᵖdoes²⁰³⁸ good,¹⁸ to the Jew ᵍfirst and also to the ᵣGreek.

11 For ˢthere is no partiality⁴³⁸² with God.

12 For all who have ᵃᵒsinned²⁶⁴ ᵗwithout the Law will also perish⁶²² ᵗwithout the Law; and all who have

"I COULD BE IN THAT BUS STATION FOR TWO OR THREE HOURS WAITING."

I grew up in Korea, after the war, with a single mom and three siblings. We were poor and didn't have a lot; I remember drawing the things I wanted to have. My mother worked seven days a week at the fish market, and she wouldn't leave until all the fish was sold. She might come back at 7:00 at night or she might come back at 9:00. The best moments of my life were when I met her at the bus station on rainy nights, holding an umbrella. I could be in that bus station for two or three hours waiting. There's not a lot a kid can do for a parent, but when she'd step off the bus into the rain and see me, she had such happiness on her face.

Some years ago, I saw this photograph at an exhibit in Paris and said, "Oh my god, that's me!" Now, it sits in my office and is the first thing I see and the last thing I see every day. It's a daily reminder, not only of me holding that umbrella but of me as a foreigner and immigrant. I came here without speaking the language but worked hard and eventually started my own fashion design company. The girl's expression is like a little child forced to become an adult, reminding herself that she has to jump into something. That's me. Looking at it, I get a powerful, primitive feeling. It brings me back to the beginning.

~ **Jene Park,** creative director and CEO, Thomas Wylde; Mar Vista, CA

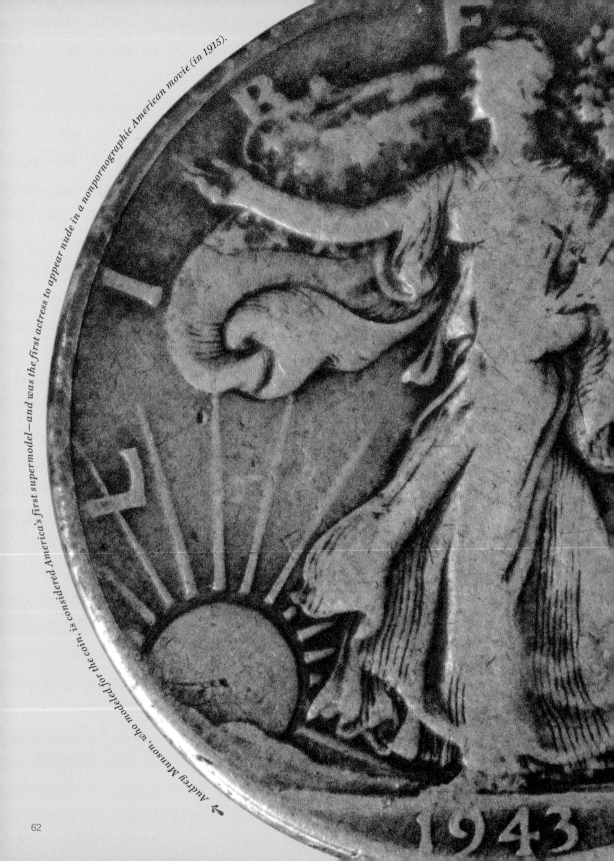

Audrey Munson, who modeled for the coin, is considered America's first supermodel—and was the first actress to appear nude in a nonpornographic American movie (in 1915).

1943

"I REMEMBER WAITING IN A VEHICLE IN THE TENSE MOMENTS BEFORE A DRUG BUST."

I've gone through a lot of life feeling like I got dealt a bad hand, and I used to look for confirmation to prove it. Like if the light turned red just as I was approaching. Even if it's not real—and I know it's not real—you still feel shitty.

That's why this coin is so special.

My girlfriend was inside a country-and-western karaoke bar in San Francisco, singing Patsy Cline. I was standing out by the street, sour about something, shuffling my feet on the pavement. I saw a flash in the gutter. Half-buried in the crud was this 1943 Walking Liberty half dollar. A gorgeous coin.

I carried it when I was in the FBI. It calmed me. Once, I remember waiting in a vehicle in the tense moments before a drug bust, before the shouting and kicking down of doors. I reached into my pocket and felt the coin; it was a grounding thing. The coin's still symbolic for me. It was the luck after feeling unlucky for a long time; it stands as the ultimate counterexample. It was like, *Open your fucking eyes, jackass.*

~ **Malcolm,** former FBI agent, San Francisco, CA

Other than your eyes and ears, the most essential tool for an NFL scout is your stopwatch. The first thing I did when I became a scout in 2013 was buy this. It fits perfectly in my hand and it doesn't beep—scouts hate beeping—and I literally take it everywhere I go. I've even taken it on vacation; there's no good reason to have it there, but a good scout *always* has a stopwatch.

Playing in the NFL is every prospect's dream. They've dedicated their entire life to the game—peewee, high school, college— and a fraction of a second can determine whether or not they make it. When they run the 40, the pressure is enormous: A tenth of a second can mean the difference of millions of dollars. At a tryout, they finish the 40, they look at me, and I look at this watch.

~ Sae Woon Jo, area scout, Atlanta Falcons; Riverside, CA

"The vase represents
the start of a life
that wasn't expected of me."

These skates shaped how the last 10 years of my life have panned out. I was working in a restaurant and trying to find a social group when a friend introduced me to roller derby. A group of girls had just started the Silicon Valley Roller Girls, and we showed up at a practice. After a year on cheap skates, I bought these. They're made-in-America Riedell skates. I chose a top-of-the-line plate and upgraded the toe stops. They were at least $500, but I was, like, why half-ass it? I knew I was going to continue with the sport as long as I could.

I have a silver medal that I won in downhill at the 1962 World Championship in Chamonix and I have 10 gold medals from Italian championships, but it's this vase that is most important to me.

It was a prize for winning a little race, for tourists, really, in the town of Selva di Val Gardena in Italy. There were maybe 12 of us—I was just 19—and I think they were hoping to give the prize to the actress Romy Schneider, who happened to be there. She was very pretty and a lovely person. But I won. The vase says it was February 26, 1954.

My father wanted me to stay in university, but sitting in the classroom didn't inspire me. That vase represents the start of a life that wasn't expected of me—becoming a member of the Italian ski team, moving to the United States. And that's why I like it. It was a little devil talking to me in my ear.

~ **Pia Riva McIsaac,** retired professional skier, Covelo, CA

For me, the skates stand for the relationships I've built. I was in these two hours a night, three nights a week, and over the years skating turned into countless weddings and baby showers and all of those things. Now my skates are kind of scruffed up, and one toe stop is glued on; once that goes, I'll have to do some major welding. But I won't ever get rid of these.

~ **Jessica Pellegrini,** recruiter, cybersecurity firm, San Jose, CA

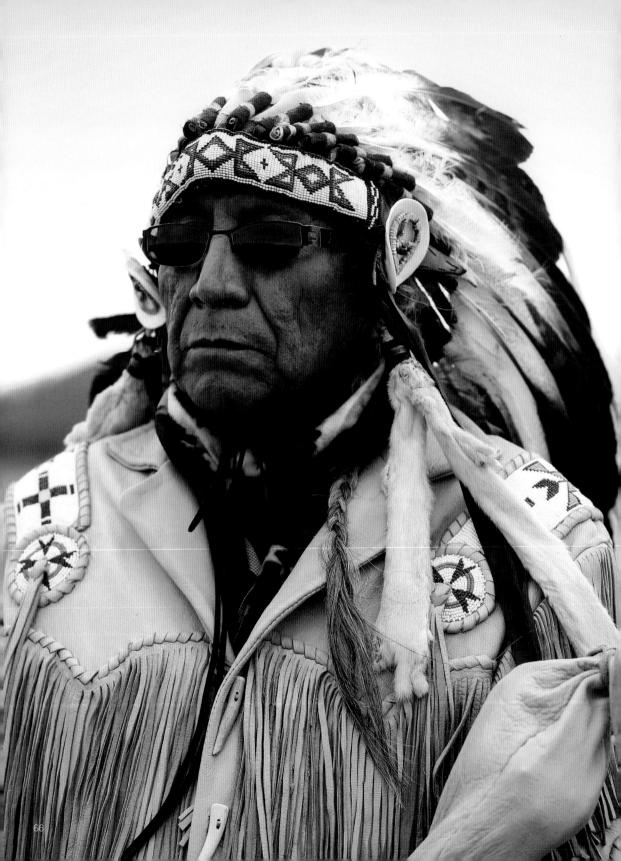

"Once you pick up the Canupa, it's like you're married to it."

The way the elders talk about the Canupa, the spirit bundle, it's a sacred object, an ancient pipe that we use to pray to the Great Spirit, Wakan Tanka. It was brought to us by a spirit woman, the White Buffalo Calf Woman. She explained to the people about the laws of the sacred pipe: to walk upon the earth in a sacred manner, to respect and honor that all life is sacred. This has been explained to me thoroughly by respected elders.

The Canupa has been with me all my life, starting at 12 or so. My great-grandmother was a sacred bundle keeper and so was my grandmother. I'm the 19th. What happens is the people don't choose or vote; we pray to the spirit bundle and the spirit bundle chooses the sacred bundle keeper. At the time, I found it so moving; I felt like I couldn't even speak. I felt overwhelmed and wondered if I was worthy of this position.

Back in the 1800s, the Canupa was brought to the reservation. It has never been removed. It has never been photographed. Once you pick up the Canupa, it's like you're married to it. You have to walk forward with that. You always have that in your thoughts. Every day, you walk with it.

~ **Chief Arvol Looking Horse,** 19th-generation Keeper of the Sacred White Buffalo Calf Pipe of the Great Sioux Nation, Cheyenne River Reservation, SD

➜ *The Canupa, a pipe made of sacred red pipestone, is used once a year in a ceremony; otherwise, it remains wrapped in buffalo hide, protected from view. It has never been photographed.*

"THESE THINGS COME FROM PEOPLE WHO CAN NO LONGER SPEAK."

I'm a surfer and I live in this little house in Malibu where I can hear the waves from my living room. I've had a corporate job for 22 years, but there was a time when I wanted to be a history professor. Over the years, I've sort of become the family historian, and of all the papers and artifacts I've collected, this cane is the gem. My great-great-grandfather Ferdinando Vignocchi carved it in Fanano, Italy, probably in the late 1880s. *He carved it!* I never met him, but his daughter was my great-grandmother and one of my earliest memories is of the cane hanging in her home as she told me old Italian folk tales in her broken English. The cane has a lion's head on one side of the handle and a fish head on the other; farther down, there are two men, one white and one black, shaking hands. If you asked 10 people if they have something older than a hundred years from their family, not many will say yes.

These things come from people who can no longer speak, but, in a way, they talk to you through their objects.

~ **Mike Monterastelli,** account executive, Canon Solutions America; Malibu, CA

"A FEW MINUTES LATER,
IN WALKS OPRAH."

I was invited to this event, the SuperSoul 100, with all of these big-name leaders and entrepreneurs—I think I was probably number 99 and a half. Anyway, I brought this little stone heart that my daughter had given me, thinking, *Well, I'm going to this fancy event with fancy people, and this is something to keep things in perspective.* So it's in my pocket and when I sit down, I sort of absently put it on the table. The chair next to mine is empty, but then a few minutes later in walks Oprah and she takes the seat. The stone was there and she asked about it, was very warm about it, and that defused my nervousness.

Since then, whenever I go into a big meeting, I bring the stone along. People tend to attach a lot to a meeting—how you might or might not be successful, ego, and all of the things you potentially get caught up in. This stone is a little reminder that you are not your ego, you are not the things people think you are, that whatever happens, it's just not that big of a deal compared to the things in life that people, when they're at their best, can appreciate—like the unconditional love a daughter can bring to her father.

~ **Jeff Krasno,** co-CEO and co-founder, Wanderlust Festival; Los Angeles, CA

"There was
NO GOING BACK,
not after this dress."

This is the first dress I bought for my daughter. She was four years old and she had been begging me for a dress for over a year when I finally gave in and bought her this hot-pink number. She wore it for the first time on Christmas Eve, and she entertained all the aunts and grandmas with her dance around the living room, so proud of how the skirt poufed out when she twirled. Her hair was still cut short, and we were still calling her by her boy name, but the writing was on the wall. There was no going back, not after this dress.

Five years on, each time I spot it hanging in the back of the closet, I'm still overpowered by the emotions I felt that Christmas Eve: sorrow at the impending loss of my son, guilt that I hadn't bought the dress sooner, terror over what was to come, and more than anything else, joy: I had never seen my child so happy.

~ Marlo Mack, producer, *How to Be a Girl* podcast, Seattle, WA

In the NBA, every year there is one winner and 29 teams that tie for last place. To climb that mountain, to reach the pinnacle of the NBA, was incredible. Not just for me and the organization but for Mavs fans around the world. There are few industries that can bring millions of people together to celebrate; they don't throw a parade when Apple or Amazon has a great year.

I've been a basketball junkie for as long as I can remember. Some people travel or bike or cook to clear their head and calm their nerves. I shoot baskets, play pickup. That's who I am. The feel of the ball leaving my hand. The arc of a shot. The sound of the ball swishing through the net is cathartic. Hitting a game winner against a kid half my age in pickup will put a smile on my face for the rest of my day.

When I was a kid, I never dreamed that any of this would be a possibility. Seeing our trophy every day is a reminder of just how fortunate I've been—and I never want to take any of it for granted.

~ **Mark Cuban,** owner, Dallas Mavericks; "shark" on *Shark Tank*; Dallas, TX

Cuban's Mavericks won the NBA title in 2011; the trophy itself is 14.5 pounds of sterling silver and vermeil with a 24-karat-gold overlay; yes, it's made by Tiffany.

"THEY DON'T THROW A PARADE WHEN APPLE OR AMAZON HAS A GREAT YEAR."

I found this in a cabinet while cleaning up at my mother and stepfather's house, just outside Denali National Park. I was in need of a magic talisman and this looked the part. It's a tiny piton, a piece of climbing gear, and it was forged in the late '60s by Yvon Chouinard, the famous climber and founder of Patagonia, which was a very small company at the time. It belonged to my father, from his early climbing days. When I came across it, it had been several years since my father and I had seen each other. I was in the throes of my own climbing

obsession and hadn't even known he'd been a rock climber. You see, my father had been an apparition in my life: admirable, mercurial, driven . . . and perpetually gone.

My mother and father met on the slopes of Mount Rainier, ran away to Alaska to work on the construction of the oil pipeline, and then disappeared into the subarctic wilderness for quite a period of time. They lived in a tiny

"A piton this small will be ripped from the rock, and the climber will plummet earthward."

cabin surrounded by millions of acres of wilderness, leading a semi-subsistence life. One day my mother fainted while carrying buckets of water up from the lake, and they made their way back to civilization to find they were expecting a daughter—me. My father, who had made a meager living as a bush pilot during those cabin days, went on to become a jet pilot and was then gone from our lives.

The piton in this necklace is the tiniest made—it weighs just 14 grams—and it bears a compelling name: the Realized Ultimate Reality Piton. Pitons serve as climbing protection hammered into the cracks of rock-climbing routes, a brake of sorts to catch the rope of a climber who falls. Such a small piece brings neither security nor comfort: If the climber falls, very often a piton this small will be ripped from the rock and the climber will plummet earthward. So if you're using this piton, you're climbing at a very high and dangerous level, perhaps achieving that mind-bending focus that is the "realized ultimate reality" of the climbing world. I was affected by the fact that I was just learning that my father had operated at such a high level in a field that I was so passionate about.

I had been leading a seductively dangerous life as an expedition guide on Denali, North America's highest peak. I'd learned to fly during that time but never did much with it. In 2010, I married a brave Denali rescue ranger, and soon we were expecting a daughter. This made me decide it was time to get a job that would allow me to come home to my family at night, so I became a commercial pilot when my daughter was less than a year old. Now I »

LEIGHAN FALLEY, HER
DAUGHTER, AND HER PITON

work as a pilot, transporting expedition climbers to faraway jumping-off points. When people discover that my father and I are both aviators, they nearly always exclaim: "He must have taught you to fly!" In fact, it was the opposite. He encouraged my brother, not me. Though I admit resentment toward him, the truth is that I found the same interests burning in my heart. And as time passed, our strangely mirrored lives eventually brought us together.

The piton originally represented my love for the mountains, my love for adventure, my love for exploration, my fear, my ambitions, my good luck. Now it represents something more: family and forgiveness. And while the piton is a bit sharp on the side and has the tendency to poke one in the jugular occasionally, I find this rather poetic.

~ **Leighan Falley,** bush pilot, Talkeetna, AK

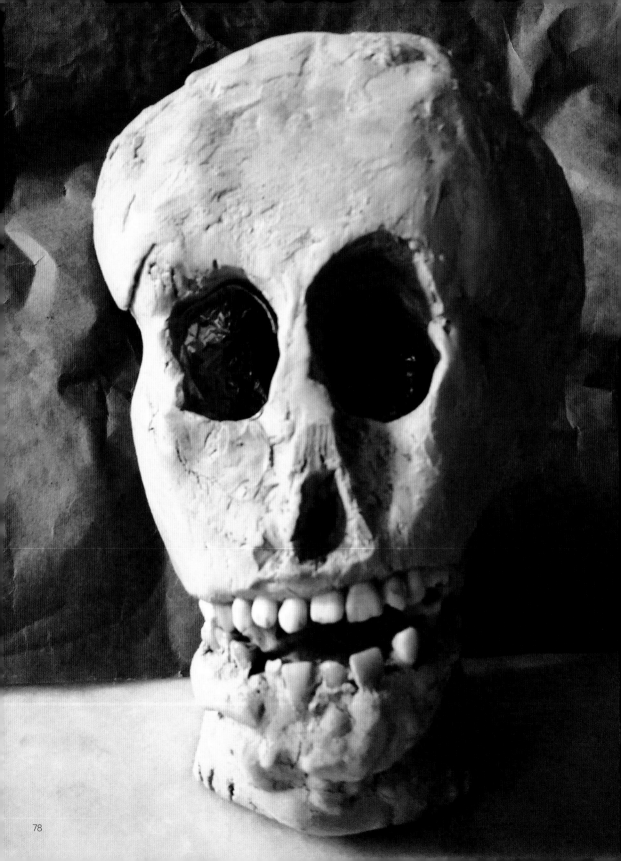

"I don't think I ever saw him without a **cigarette** in his mouth and a **whiskey** at hand."

Living here, you gotta be ready to go. You look in the rearview mirror and whatever's back there is just gone. Could be flooded, looted, or blown out of your house. So you prioritize. You grab Grandma's silver, the guitars, liquor, pictures, stuff for the kids. And this—I'm not leaving this behind. I got it 31 years ago and have had it through one divorce, three apartments, four houses, and seven evacuations, including Katrina.

In the middle of driving around the Delta—this was probably '84 or '85—a friend took me to meet James "Son" Thomas in Leland, Mississippi. Son was a gravedigger and a Delta bluesman, once famous in his way. He looked like he was made out of dust, very frail, but I don't think I ever saw him without a cigarette in his mouth and a whiskey at hand. He played guitar for white-boy frat houses and on the porch of his shack.

Son used the clay from the graves he dug—river clay, what he called "gumbo"—to sculpt little animals and skulls, using corn for teeth, which he would sell from his porch. I was living in New Brunswick, New Jersey—this was after I met him—which was near a Colgate-Palmolive facility. I befriended some of the guys who worked in the Colgate lab and they would trade me human teeth for guitar strings. I'd send the teeth to Son for his skulls.

Most people don't find the skull charming, but this connects me to a love of music and to Son, who was like an alien on Earth. He once told me about the time his art was being shown in DC and he met Nancy Reagan. "I didn't understand a word she said," he told me, "but she smelled nice." Once, I brought Marshall Crenshaw to meet him and Marshall started playing the *Flintstones* song. Son recognized it, and I'd never seen him happier.

Son made this skull especially for me, with the human teeth. It's heavy. It's crumbly. It's almost ephemeral. The thing Son said when he gave it to me was, "I've buried *everybody*. You could be rich, you could be poor, but you're going down as clay." For me, this is a reminder of that, of mortality, of ashes to ashes, a reminder that we all return to clay.

I put the headstone on Son's grave in '96. I loved that guy.

~ **Skip Henderson,** box-guitar maker and folk artist, New Orleans, LA

My dad won this at the fair, and the deal was that my sister and I had to share it. We *hated* that idea, but eventually we came up with a set of rules for who got it when—a really complicated set of rules that we then totally forgot to follow. Somehow, I ended up with the glass—which would have meant the world to me at the time. I love the idea that something I'd have fought and died for at one point in my life now just holds my Diet Coke.

~ Sarah, between jobs, Portland, ME

"All these solitary pursuits were his way of
GETTING AWAY FROM THE OLD LADY."

When I was growing up, my grandfather Bill was sort of rough-and-tumble. He had motorcycles, lived in the woods. I'm pretty sure I cracked my first beer with him. He was my favorite. My other grandfather I called Opa. He was a fussy little German. We lived in the same town and I liked him, but I felt like I had to be polite around him. In the end, he had a way bigger influence on me.

Opa worked in a paper factory in Paterson, New Jersey. He was a tinkerer and a photographer, an avid stamp collector, a gardener, and he had a little woodshop. My grandmother was a battle-ax and all these solitary pursuits were his way of getting away from the old lady.

I have Opa's awl. It's a Sears Craftsman from the '50s, made in the USA—no Chinese shit for Opa—and it's virtually indestructible. I have some of his cameras on a shelf, and I have his pocket watch somewhere, but I've used his awl—I've had it in my hand—almost every day for the past 25 years. The guys at the woodshop where

I used to make furniture called it "Grandpa's Awl." It's got 1,001 uses. I've broken a lot of ice with it. Defrosted a freezer with it. And pretty much every time you want to put a hinge on the door, the first hole-poke is with the awl.

Opa wasn't a pro woodworker. He never sat me down and showed me how to do anything, which is too bad. Still, the love of woodwork snuck in somehow and became a part of my life.

The last time I used Grandpa's Awl was a few days ago to open a tube of Liquid Nails, a construction adhesive. It stuck to the spike, and I felt a little guilty about it. That's exactly why Opa never let me use his tools.

~ **Robert Jaeger,** owner, Born to Run San Francisco dog-walking service, Napa, CA

"Dream **big dreams.**"

I had lunch with President Obama and mentioned that my son, who was 16 at the time, had an interest in diplomacy. Later, the president gave me a signed pocket atlas for him.

Part of not having privilege is that you see less, and one of the things I want for my son is for him to see more. To be handed this atlas by a black man, much less the president of the United States, was very meaningful. The inscription reads, "To Samori — Dream big dreams . . . the world is big and full of challenges, but it's still yours to shape!"

~ **Ta-Nehisi Coates,** national correspondent, *The Atlantic*; New York, NY

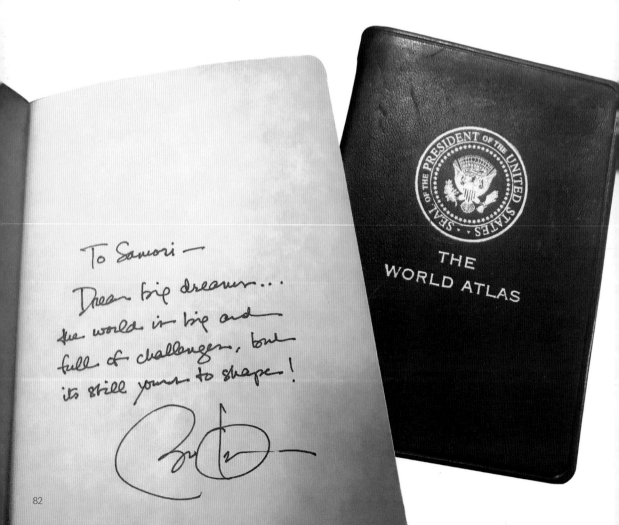

I worked on the Mars rover for nine years and then there I was sitting down on the rug in my apartment, emptying out all the pieces and building it. I remember feeling unrestrained happiness: *I've done something that merited a Lego set!*

I grew up on Lego. If there was a way to go back in time and show the childhood me that the adult me inspired a Lego toy? I mean, I might be like, "Whatever, old man." But I don't think so.

~ **Bobak Ferdowsi,** systems engineer, Mars Curiosity rover; Pasadena, CA

"I'VE DONE SOMETHING THAT MERITED A LEGO SET!"

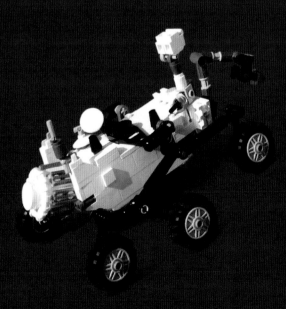

How many parts in a Curiosity rover? Lego's set: 295. The real rover: 50,000.

I don't know how old it is and I don't know where my mother got it. But of the ridiculous number of things I cherish, this one has the earliest provenance in my life and it affected me in a very substantial way. It's a Grand Tour souvenir, a replica of the Arch of Constantine in Rome, made of marble, the kind of thing they produced in the 18th and 19th centuries to sell to wealthy people who went to see architectural wonders—in Italy, mostly.

The thing about this is that when I was a little kid, six or seven, my mother allowed me to play with it. This precious object. She trusted me with it, you know, not to hit it with a hammer. That meant so much. It was always on my floor, it was always part of my games.

Of course, at one point, I *did* break it, and she fixed it for me.

This marble arch created a fascination in me and I fell in love with architecture as a child. Scale and proportion, balance and color, functionality—the design ideas embodied in this arch influence many of the things I do today, whether it's creating displays for Estée Lauder or events for the Whitney Museum.

But there's another layer to this arch. In the early '80s, all of my friends were dying and I assumed that I was going to die as well. There was no test then and you didn't know if you were infected or not, so you had to hope and you had to live your life. It definitely put a fire under me to do the things I had always wanted to do—and I wanted to go to Paris. Neither my mother nor I had ever been out of the country, so I took her to Paris in '84. While we were there, we happened to stumble across a full replica of the arch not far from where we were staying. That was incredible. My mother wanted to see Rome before she died, and so in '98 we went and, very intentionally, saw the real Arch of Constantine then.

~ **Geoff Howell,** president and creative director, Geoff Howell Studio, New York, NY

"I FELL IN LOVE WITH ARCHITECTURE AS A CHILD."

Arch rival: Howell's souvenir is a replica of the massive Arch of Constantine, built in 312 AD, which stands 69 feet high, 85 feet across, and 24 feet thick.

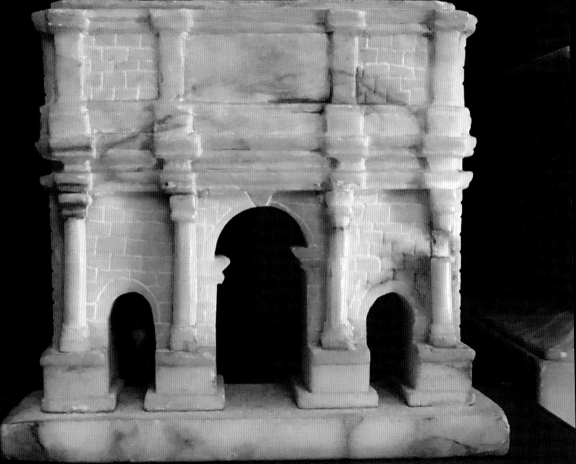

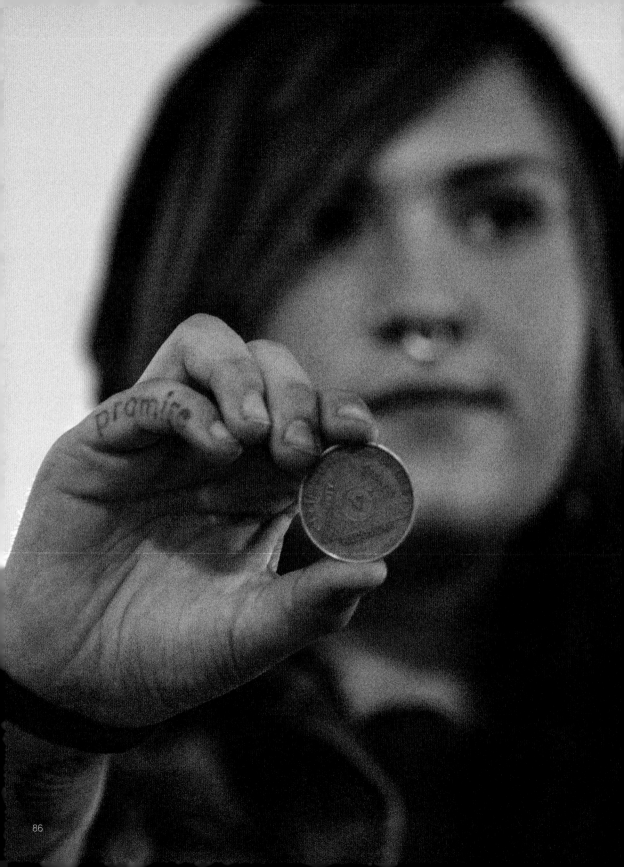

"MAYBE THERE WAS SOMETHING ON THE OTHER SIDE OF WHAT I HAD."

I was straight off the streets, coming down off heroin, alcohol, and Xanax, and just sitting in the corner at this meeting, shaking, vacant. A middle-aged woman came up to me. She had tattoos and a scarred air to her, but you could sense a well-being.

"You can have this," she said, and she handed me this coin. "It's available to you as well."

She meant sobriety. All I did was look up at her and give a half smile. I didn't believe her.

When you're as wounded as I was, you have a lot of people telling you, "There's hope, there's hope," but it all just felt like talk. I had this voice in my head—my own voice—saying, *You're never gonna make it, you're destined to lead a life of misery.* But around six months sober, that began to dissipate, and I remember looking at the coin every day and being like, *Yeah, maybe I can do this.* The coin surpassed being an object. It's the first tangible thing that gave me hope that maybe there was something on the other side of what I had. You hold it— it's heavy—then you look at it and it's . . . it's freedom, it's fucking freedom.

~ **Etta Thordarson,** neurofeedback specialist, Santa Ana, CA

I think I was in preschool when I got my first journal. I didn't know how to write, so when I'd get home from school with all of these things I wanted to say, my parents would write them down for me in the journal, verbatim. Sharing all these thoughts became, like, natural to me, and later that made it easier to let my emotions out. Now that I'm writing songs, I go back to my journals—I have, like, six or seven—because I like being able to look back and see who I was at a certain time and how my brain worked, and if I was sad or in a bad time that I got over it.

~ **Ariel Martin (Baby Ariel),** recording artist and online entertainer, Pembroke Pines, FL

"LATER THAT MADE IT EASIER TO LET MY EMOTIONS OUT."

The front of the sweatshirt is the cover of Webb Wilder's first album and the back is his deadpan credo: "Work hard. Rock hard. Eat hard. Sleep hard. Grow big. Wear glasses if you need 'em." I associate this with the late '80s and early '90s, when I was just out of school and living in Nashville, out of my small hometown and beginning to lead a less sheltered life. I had this record on constant rotation. Webb Wilder may have been my first clue that interesting things aren't always identified by national popularity. I come across this sweatshirt whenever I go through old clothes, but I can never bring myself to throw it out.

~ **Whit Coppedge,** network architect, UNC Health Care, Chapel Hill, NC

IMPORTANT MESSAGE

FOR _Daniel_ TIME _12:30_ A.M. / P.M.
DATE _10-31_

WHILE YOU WERE AWAY

M _Dave Brubeck_
OF _679-7000 . Rm 905_
PHONE No. _Hilton - Skokie_
AREA CODE · NUMBER · EXTENSION

	PLEASE CALL
TELEPHONED ✓	WILL CALL AGAIN
CALLED TO SEE YOU	RUSH
WANTS TO SEE YOU	
RETURNED YOUR CALL	

MESSAGE _Says "Hello." Thanks for always being there & so helpful. If you have time call him!_

SIGNED

TOPS 3002-P · LITHO IN U.S.A.

I was young, maybe 27, and working for Atlantic Records, promoting a concert by the jazz legend Dave Brubeck. About a mile from the venue, which was an hour or so north of Chicago, the battery light in my car flashes on.

Then other lights go on, and I realize the car is failing. I end up dead-rolling into a gas station. The owner is just closing down but offers to drive me to the show.

I hop out of his tow truck just as Brubeck's getting out of his limo. Brubeck finds this hysterical, and after the show he gives me a ride back to the hotel in Chicago and we have a few drinks at the bar. A couple days later, I walk into the office and get this sweet message.

I had a long, long career in the music business, and my goal was always to get inside, skip the red tape, and be there for the artist. So whether it was retrieving the diaphragm Bette Midler left in a hotel room or getting Blind Faith to approve their famous album cover—both of which I did—I always wanted to connect the dots for them, to be a safe harbor. For me, Brubeck's message is a sign that I did that.

~ **Daniel Markus,** music industry artist manager, Marina del Rey, CA

This belonged to a friend of mine. In our 20s, we spent an ungodly amount of time camped out around this thing, blowing smoke, listening to music, and wondering if we'd ever do anything important with our lives—then we'd kill more hours analyzing what "important" even means. I said things over this ashtray I've never said anywhere else. When she moved to Boston some years ago, she gave it to me in a funny little ceremony. I think of her when I use it, which she loves.

~ **Anonymous,** massage therapist, Boulder, CO

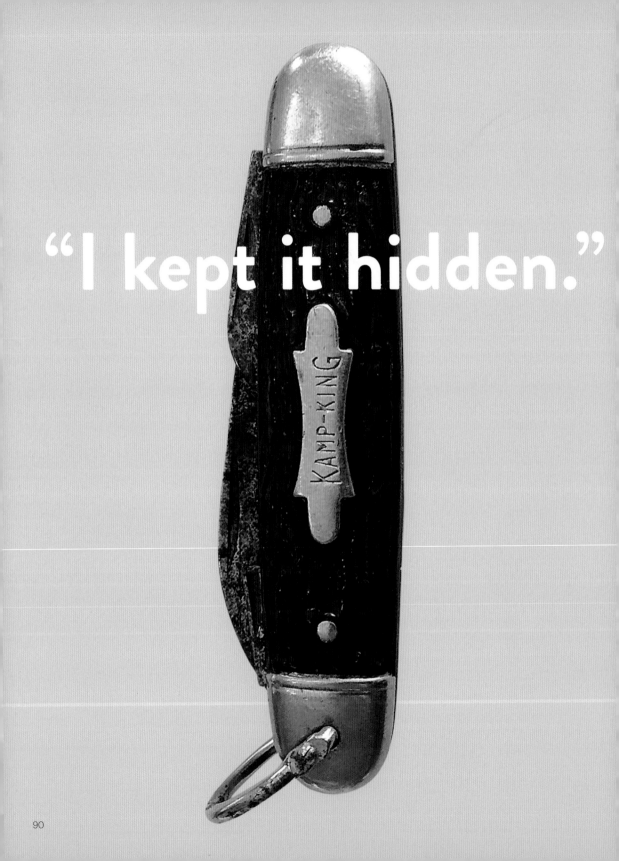

"I kept it hidden."

The knife was perfect. Look at it. It's a boy's dream. My dad made me promise to use it safely, and then he released me into the backyard. I remember opening each of the blades and thinking of all the ways I could put them to use. Then I went straight to the big tree at the far end of the yard and carved my initials. I called my dad to come look. He saw the damage I'd done and took the knife from me.

I got it back a few days later, but I was so scared of losing it or having it taken away that I kept it hidden. It was enough just to have it and to open the blades every once in a while and get that sort of Tom Sawyer feeling. I don't get that feeling anymore when I hold it, but I do get a strong flash of memory of that feeling, which is kind of cool.

~ **David,** art teacher, Salt Lake City, UT

From 2007 through 2011, I was part of the Ohio University Marching Band. I played the mellophone, sort of a fat trumpet, and when I finally got my band jacket, it was a really, really big deal. Everyone customizes their jacket, like by marking the place on the Ohio patch where you come from—I'm from the Akron-Canton area, so there's a hole there—and having people who've been important to you etch their initials on the white buttons.

Everyone who plays in that band is hyper-focused, working as a unit, and anyone who has ever worn that jacket really, really cared about that ensemble. Even though I work with wonderful bands every day for my job, I'm not sure I'll ever achieve that sort of intensity and cohesion again.

"I'M NOT SURE I'LL EVER ACHIEVE THAT SORT OF INTENSITY AGAIN."

My husband and I both work in rural schools; we're very liberal, and after the 2016 election we noticed a change in tone—kids talking about "building a wall" and other rhetoric we thought was really divisive. That made me uneasy, and one way I've found to ease my discomfort has been to prepare: canning food, stocking up on rice and beans, making sure we have our guns, ammunition, stuff like that. I'm not an obsessive prepper, but the tension in the country has really ratcheted up, and, between that and all the natural disasters, we feel there's no reason *not* to be prepared for all sorts of things. My husband knows that if something happens when I'm not around, he should grab a bag of clothes, our dogs, some family photos—and that band jacket. I want that jacket with me.

~ **Julia Brewer Olson,** middle school and high school band director, Athens, OH

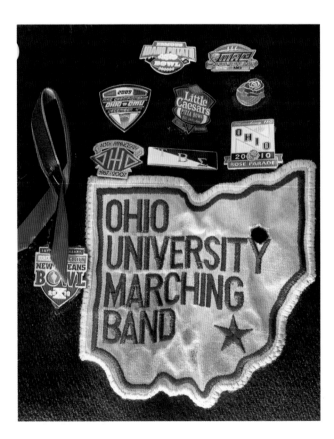

"It has more to tell you than you can quite grasp."

I've always been fascinated by the concept of pretend. I remember looking at advertising images when I was young and trying to figure out which ones showed real life. As a girl, you're presented with a vision of womanhood that's incredibly potent and saturated. I remember wanting to emulate that vision—but I also wanted to be appreciated as *me*. This wig, which I found online a few years ago, is a symbol of that friction, and that's why I love it. The wig is all about that decision to pretend: It looks like hair, but it's so obviously not hair—and yet we pretend it *is* hair. The wig is absurd. It captures so many of my thoughts. It's like an art object, in that you really have to stop and think about it. It has more to tell you than you can quite grasp.

~ **Denise Prince,** visual artist, Austin, TX

RAY JOHNSON III (RIGHT), HIS SON, AND HIS FATHER

s brainwashed by my father at an early a

s **a prison guard** and spent money
didn't have to buy this jacket. I
nd grade and wore it every day to
etimes I'd button the top button
as a cape, and sometimes I'd tie it
waist. But I wore it everywhere. I
ket on October 19, 1981, as I raced
school to see Rick Monday hit a
n the top of the ninth to send the
the World Series.
dger fan because I was brain-
ny father at an early age. But it
later that I started to realize what
s meant to him: They were the

I can only imagine what it must have
for him, at 14, to believe change was
and that he or his cousins or friends
had a chance to be accepted as an eq

When I moved out of my parents'
the jacket came with me. Some years
son discovered it in the closet. *What's
Can I have it?* It fit. The next time m
came over, I said, "Go get your jacket
Pop-Pop." My son put it on and said,
wear it to school?"

I turned to my dad. He was giving
knowing look that said, *I'm glad you*

~ **Ray Johnson III,** electric distribution

"We form these attachments to objects and they become TOTEMS OF OUR PAST."

My brother decked me once in a fight over some pancakes but mostly we had a good, competitive relationship. We both collected baseball cards, but where my brother really tracked his cards, had full collections from each year, I was two and a half years younger and just happy to have a card that had cool colors on it. So when I somehow got a 1963 card with Willie Mays *and* Stan Musial but wouldn't trade with him, it stuck in his craw. It was a unique card—it said "Pride of N.L."—and he was pissed that I had it and didn't really value it and wasn't going to take care of it. He put a lot of deals on the table, offering me a mess of cards for it, cards and money, he'd set the table 20 times. Like that. But I wasn't giving it up.

And then he got a knife. It was plastic, like a prop from a movie set, silver blade, leatherish handle, really cool. He did kung fu moves with it, and it just looked like the kind of thing that gave you adventures. I broke down and traded the card for it. I immediately took the knife outside to show my friends and goof around. I can't remember exactly what happened but the knife flew into this big wall

of ivy. It was gone. I was devastated and tried to talk it through with my brother: *I only had it for a few hours, it isn't fair, I want my card back.* That's where it ended.

Until my 40th birthday. My entire family gets together and in the middle of opening presents, my brother hands me a small package; it's a stack of cards, each in a plastic sleeve. *Lovely,* I think, and start flipping through them. And there it is: Pride of N.L.

I don't know why, exactly, but it made me cry. It's like we form these attachments to objects and they become totems of our past. There were a lot of emotions wrapped up in it: Envy. Jealousy. The older kid and the younger kid. It wasn't just a card.

~ **Anthony Weintraub,** filmmaker, New York, NY

PRIDE OF N. L.
Willie Mays • Stan Musial

"She got some sort of strange feeling and started freaking out."

My mother and her sister Ana Julia were, like, inseparable. Ana Julia, who was 10 years older, called my mother *Chiquita*. She took her *everywhere*. One day, when Ana Julia was 27, she wanted to bring my mom to a party, but my mom didn't want to go. This was unusual. When Ana Julia pleaded, my mom ran and hid; her school was going on a field trip to a lake that day and she really wanted to go with her classmates. So my mom went to the lake. But while she was there she got some sort of strange feeling and started freaking out. She rushed home. No one was there, so she just sat on her bed in her wet bathing suit, crying without really knowing why. After, like, half an hour, three police officers came to the door and told her that there had been a terrible accident, that the jeep Ana Julia was in had flipped many times, and that everyone was in critical condition. In fact, Ana Julia had died.

My relatives always tell me I remind them of Ana Julia—the way I do my hair, my interests in school, my mannerisms. This is the ring she was wearing that day; there's a little chip on it from the accident. It was given to me for my 21st birthday. When I wear this ring, I feel like I have a guardian angel watching over me.

~ **Cindy J. Araica,** student, San Francisco State University, San Francisco, CA

"I used it in prison and I use it today."

I'd been printing money since I was 15. I had a long run. I'd always try to do the right thing, but then I'd get impatient and I'd start printing. I was 33 when I finally got arrested. I had $500,000 in printed money and I ended up going to prison for six and a half years. What got me through it was this paintbrush, which an inmate gave to me. This brush is my freedom.

They had a painting class in prison. When I joined the class, I was the famous counterfeiter; I was a celebrity. But I had never painted before and when the teacher gave everyone a flower to paint, mine turned out terrible. I said, "I can't paint no flower," and I dropped the class. I was out in the yard and the teacher came up to me and said, "You have a way with the colors. What would *you* want to paint?" I said, "The only thing I want to paint is money."

I brought in a picture of an 1896 dollar bill. He said it would be too complicated.

But we stretched the canvas, like the masters, and I started. The painting took me a year. Painting taught me the thing I was missing the most in my life: patience.

When I first got out of prison I was a janitor, cleaning toilets and making 15 bucks an hour, which was hard because when you're printing, you're used to having so much money. But I kept painting and eventually I started getting shows in galleries, and I also have a commercial painting company, Artwrks. Eighty-two percent of people go back to prison after three years. I've been out four years.

This brush is a detail brush. I used it in prison and I use it today. It's for cross-hatching on the edge of the bills and the lines that go around the numbers. This brush has kept me free.

~ **Art Williams,** artist and painter; counterfeiter of the most secure banknote ever created; Bridgeport, IL

MILITARY PAYM[E]

SER[I]

ONE D

ONE

ONE

ONE

1

1

1

FOR USE ONLY IN UNITED STATES MILIT[ARY]
AUTHORIZED PERSONNEL IN ACCORDANCE

DETAIL FROM *MILITARY PAYMENT CERTIFICATE*, BY ART WILLIAMS

"MY TEACHER WON THE BATTLE."

We made these bears in second grade. I clearly remember arguing with my teacher that I needed to sew up her stomach, while my teacher insisted that I leave it open so I could put treasures inside. *Why would I put treasures inside a hole filled with stuffing?* My teacher won the battle and the bear's stomach is still open, but I've never once put anything inside it.

As an adult, I've spent long periods working with refugee children in Bosnia and other war-torn regions. They've lost so much, including the ability to have a say in most aspects of their lives. That always hits me when I come home and my treasure chest bear is lying on my pillow, empty.

~ **Elana Haviv,** founder and executive director, Generation Human Rights; Santa Fe, NM

"It's the Mercedes of telescopes."

My dad used to do some advertising and paste-up work for a guy who owned a laser company. This guy was notoriously late in paying; I think it had been a year, when my dad, being frustrated by this, gets the guy to give us a telescope instead of a check. It was a Questar 3.5-inch and it came in a leather case, with that new leather smell. It's a gem, a superior piece of equipment, the Mercedes of telescopes. I was 13, and it meant the world. When I look at it now, it personifies my early interest in stars but also my dad's commitment to that interest. He was so supportive. Not only would he drive me to the golf course to see the night sky, but *Dad let a whole year of payment go to get this for me.* In 1991, he joined me on an expedition to see the solar eclipse in La Paz, Baja; we brought the Questar with us.

~ **Dr. Carter Emmart,** director of Astrovisualization, American Museum of Natural History, New York, NY

M C A ARTISTS, LTD. *Agency*

MCA

Address Reply to
598 MADISON AVENUE
NEW YORK
PHONE PLAZA 9-7500

December 30, 1954

Mr. Bert McCord
The New York Herald Tribune
230 West 41st Street
New York, New York

Dear Bert McCord:

In a book recently published by Mr. Eric Bentley, a reference
is made to the plays, A STREETCAR NAMED DESIRE and DEATH OF
A SALESMAN, as follows:

"To me the evening was of interest chiefly as to the
latest essay of Elia. We are told that Mr. Kazan was
virtually co-author of "A Streetcar Named Desire" and
"Death of a Salesman", even to the extent of changing
the character of the leading persons; it is arguable
that both plays would have failed without his changes."

The undersigned wish to bring to the notice of any interested
persons the utter untruth of this entire statement. As well,
that in this same book, but in an addendum entitled, "After-
thoughts", Mr. Kazan has himself disclaimed any co-authorship
whatever, attesting too, that he did not in any way influence
the conception of any characters in these plays.

As it stands, the book leaves, and in our opinion, is designed
to leave an ambiguous impression, its author, in effect,
taking responsibility neither for the truth of the original
statement nor for Mr. Kazan's disclaimer. We wish now merely
to remove any such confusion, and to say that Mr. Bentley's
statement is a lie.

Yours truly,

Tennessee Williams
TENNESSEE WILLIAMS

Arthur Miller
ARTHUR MILLER

"WHAT YOU'RE

ACTUALLY TRYING TO PRESERVE

IS AN *IDEA*."

As a journalist, I've spent a lot of time study-ing doomsday scenarios and how decisions get made about what to try to save. During the Cold War, government planners realized that it's not enough to save people—what you're actually trying to preserve is an *idea*. That's why they developed detailed plans to save the Declaration of Independence, to save Lincoln's Gettysburg Address and the Liberty Bell—the historical totems that have bound Americans together generation by generation.

In some ways, for me, an item like this letter is a micro-cosm of that concept. It hung on the back of the bathroom door in my grandparents' farm-house in Vermont, a wacky room decorated floor to ceiling with odd mementos, artwork, the strange things one comes across in the course of one's life. It's a letter to my grandfather from Arthur Miller *and* Tennessee Williams, signed by both of them, about a controversy that was unfolding in the theater world at the time. My grand-father was the theater critic for the *New York Herald Tribune* in the '40s and '50s—the real glory days of Broadway, the peak of Rodgers and Hammerstein, the Great American Songbook, Sondheim, and of course, Miller and Williams. He got to experi-ence that world in an incredibly personal way. My grandfather was a huge influence on my father, who became the head of the Associated Press Vermont bureau, and my father was a huge influence on me.

The letter is a link back to someone I barely knew but whose legacy I live on a daily basis. It also speaks to this thing my family has done for almost a hundred years now—writing, jour-nalism, storytelling. It speaks to continuity.

~ **Garrett M. Graff,** author, *Raven Rock: The Story of the U.S. Government's Secret Plan to Save Itself—While the Rest of Us Die*; Burlington, VT

We had tried to get pregnant for so long, for years and years, and when we finally adopted A.J., we received so many adorable clothes, blankets, stuffed animals . . . and a tie. Our friends in Stockholm sent it. It came in a box, rolled up with a little clip. Nobody here would give that as a baby gift. I was, like, *Huh, a tie? When would a baby wear a tie?* And I set it aside on a shelf in his room.

I live in a state that isn't adoption-friendly and so after you take the baby home, the birth mother has 45 days to change her mind. Forty-five days is a long time. My lawyer said, "Think of it like you're babysitting for 45 days"—which is just impossible.

When Day 45 finally arrives, we all dress up to go in front of a judge and make it official. I get A.J. into a little sweater-vest with a cute button-down shirt and I think, *I wish we had something a little more special to mark the occasion.* And it hits me: the tie! It matched perfectly.

This was really a big moment—A.J. legally becoming our child—and I will never forget that day for so many reasons. I had been holding it together through the adoption process, then holding it together for these last 45 days, and after the papers were signed, I totally broke down. I could breathe. *He's ours.* When you want something so badly, and there are years and years of trying, and then it finally happens . . . It's just *joy.* Every time I see that little tie, all of that joy comes rushing back.

~ **Fran Hauser,** start-up investor; author, *The Myth of the Nice Girl: Achieving a Career You Love Without Becoming a Person You Hate*; Bedford, NY

"I had been holding it together through the adoption process."

"It was one of those

surreal moments

where everything is going in slow motion."

I was 21 in 1969, in Vietnam doing special ops and long-range recon and all kinds of crazy shit. On one particular mission, I was out with two other guys in Cambodia, counting sandals, as they say. We weren't supposed to be in Cambodia, but my mission was to set up a listening post to count the North Vietnamese soldiers passing by and call in their position for a mortar strike. It was the middle of the night and we were more than a mile away from the closest friendlies when I hear 21 of the enemy moving right next to us, setting up an ambush. They're maybe 15 yards away.

One guy in their group had a transistor radio and at 2:37 a.m.—I remember that—he starts playing rock 'n' roll. Crosby, Stills, Nash & Young. Eric Burdon and the Animals. The North Vietnamese soldiers loved American music and knew all the songs. One of them starts singing along in English. And then "House of the Rising Sun" comes on and he lays into it. It was kind of shocking.

There's 21 of them and 3 of us. If we'd moved, they would have heard us. And we were so close that if I'd called in the mortar, it would have killed us, as well. And so, very quietly, I start singing "House of the Rising Sun" in Vietnamese. I said to them in Vietnamese,

"Tonight is a good night for rock 'n' roll and not for death."

It fucking worked, man. We spent the night singing rock 'n' roll. It was one of those surreal moments where everything is going in slow motion because it can go to shit in a second. The whole time, I'm ready to call in a mortar strike and take everyone out, including myself. As day breaks, we go our own ways. I head back to my platoon and file a false report: *I didn't see anyone.*

In the early '90s, I'm doing some work in East Hampton, New York, and I see that Eric Burdon is playing at this little club. During the show, people are screaming for "House of the Rising Sun" and Burdon says, "I hate that fucking song." Afterward, I approach him and tell the story. I tell him, "I'm alive today because I happened to know your song in Vietnamese"—and we spent all night drinking scotch and talking about how music can transcend the horrors of war.

This bullet is a reminder of that night in Cambodia. I was saving one round in case we were overrun; it was either going to be for me or for the last person I'd ever see. It reminds me of all of the people I lost in Vietnam, the majority of my platoon, and of the people I killed, and of human beings in all of their frailty and magnificence and brutality.

~ **Gordon Cronce,** alternative medicine healer, Sedona, AZ

"He kept an African lion just off the lobby."

When my dad was building the Roxy Theater in Mitchell, South Dakota, in 1933, the manager of the big Paramount Theatre in town promised he'd run him out of business in six months. But my dad always managed to outwork them or outwit them. He even bought an African lion, which he kept just off the lobby so you could see it feeding before the movie.

Once, when I was about nine, the projectionist quit right in the middle of a matinee, so my dad started projecting. He showed me how to thread, handle two projectors, and make the changeover; he even built a little stool for me so that I'd be high enough to see the cue marks on the screen. It felt like my entry into the adult world, like an expression of his confidence in me.

We're digital now, but this old projector, a Simplex E-7, sits in one of the theater's hallways. It makes me happy every time I walk by. It brings me back to how I got started in the business, and it represents my dad's ability to do whatever it took. No matter what was thrown at him, he always powered through.

~ **Jeff Logan,** owner, Luxury 5 Cinemas, Mitchell, SD

The first design of the Simplex projector was sketched in 1908 in the backroom of the O'Keefe Saloon in New York's Grand Central Station. On the back of a menu.

I don't necessarily want to go into the details, but I keep this key ring to remember that night.

~ **Anonymous,** customer service representative, Madison, WI

MIDWAY MOTOR LODGE
3710 E. WASHINGTON AVE.
MADISON, WIS. 53704
227

DROP IN ANY MAIL BOX
WE GUARANTEE POSTAGE

"OVER THE YEARS, THE ROCK HAS TAKEN ON MORE MEANING."

A girlfriend gave me this rock on my 20th birthday, in 1972. At the time, I had a T-shirt that said JERSEY JESTER and I'd wear it all the time. She painted the rock to look like my shirt. It meant so much to me that she took the time to do that. Over the years, the rock has taken on more meaning: It keeps me tied to how much I'm shaped by growing up in New Jersey. It reminds me of the kinds of hopes you have when you're a 20-year-old kid, of the joy of dreaming, and of not letting life get in the way of your dreams. Forty-six years later, the rock still sits on my desk.

~ **Lonnie Bunch,** founding director, Smithsonian National Museum of African American History and Culture, Washington, DC

➤ *The museum has collected over 40,000 artifacts from families around the country. "I knew in my heart," Bunch has said, "that so much of the history was in the basements, trunks, and attics of people's homes."*

"Part of going to **Paris** was realizing how precious our lives are."

Recently, I was on a three-month tour, living out of a suitcase and sleeping in hotel rooms. That changes your mind about how little you can actually live with. When I got home, I saw all the frivolous stuff I had and started asking myself, *What am I really attached to? Why am I attached to it?* Since then, I've been trying to get rid of the things I don't cherish. So I have a newly cleaned-out bookshelf and on that shelf sits a photo book that my aunt made of a trip we took to Paris.

One of my mother's lifelong dreams had been to go to Paris. So her sister and I cooked up this trip as a surprise for Mother's Day. We'd never gone on a trip, just the three of us, and my aunt and I spent months figuring out where to go and what to do. Seeing my mother

take her first bite of real French bread, hearing her say, "There's the fucking Eiffel Tower!" made everything worth it. One day, we went to a fancy restaurant and I was having a martini. I swallowed wrong and literally spat out vodka, drenching my mom, which got *everyone's* attention. My aunt is very proper, but we all started laughing uncontrollably, just loving how ridiculous life can be. The whole trip was like that, us against the world.

My mom, who is 70, grew up with two sisters. One passed away from cancer and my mom was diagnosed with it 15 years ago. So part of our going to Paris was also about realizing how precious our lives are and taking the time to commemorate the moments we have together. Now my aunt is going through extensive chemo; if we'd waited, I don't know if the trip would have happened.

My aunt made this beautiful photo book of our trip and gave us each a copy. It's so carefully put together—the colors and backdrops, the time line and inside jokes. My favorite picture is of my mom and aunt together in Monet's garden. They're dressed in white with these amazing gardens around them, and they just look beautiful, the two of them in this place, experiencing this moment.

~ **Rachael Yamagata,** singer-songwriter and pianist, Saugerties, NY

"I began my wedding vows with words from this book."

This is my holy text. It's the same copy I read in 11th-grade English class. I was one of two black kids in my entire high school, and reading *Their Eyes Were Watching God* was the first time I'd felt deeply seen. It's a book about a black woman's journey to self-revelation and love, and it made me think it was possible, in some world, some years down the road, that I would be able to write my own journey of self-discovery and love.

When I was 16 and a half, the text was all about the romance, you know, all about the love, but every time I returned to it, there were different layers. I realized later that there were feminist layers, racial layers, the way she's growing into becoming a writer, the way she invented her own language sometimes, writing the way her people spoke.

It's been with me on so many levels. As a trans woman, the disclosure piece, in telling your story to someone you care about, someone you hope to have a relationship with, is fraught with all kinds of anxiety and fear and potential loss. So when I wrote my first book, *Redefining Realness,* I stole Hurston's structure, which opens up in present-day with a woman telling her story to someone she deeply cares about.

I actually began my wedding vows to Aaron with words from this book: "He looked like the love thoughts of women." When I was younger, I was lovesick even though I had no experience with romance or anything, but the first time I read these words, I remember saying to myself, "Oh my god, I want somebody who looks like the love thoughts of women!"

It's the book that has been on every single bookshelf I've ever had since the 11th grade. Now, it's on the desk where I write. It's the book that I turn to.

~ **Janet Mock,** author and activist, New York, NY

➤ *"Love is lak de sea. It's uh movin' thing."*
 ~ *Zora Neale Hurston,* Their Eyes Were Watching God

ZORA NEALE HURSTON

Their Eyes Were Watching God

1987 / 50th ANNIVERSARY
STILL A BESTSELLER!

"A MASK COULD HELP ME BECOME THE DIRTY WRESTLER I KNEW FANS WANTED TO SEE."

I'd been wrestling under my name, Dick Beyer, for a few years when a promoter in California tells me, "We're going to put a mask on you and you're going to wrestle as The Destroyer." They hand me what looks and smells like a moldy potato sack made of wool. It had tiny eye slits, no ventilation, and itched like hell. This was 1962 and a promoter could make or break your career, so I agreed to try it. I won the match and realized that a mask could help me become the dirty wrestler I knew fans wanted to see. But the ventilation!

My wife was a good seamstress—she could make her own clothes—so we went to the Woolworth in Los Angeles and bought a girdle. I still remember: It was a size 10 small-tall. She turned it into a mask with colored stitching to match my tights. I could see, I could breathe, and when I put it on I became 6 foot 6 instead of 5 foot 10. I never wrestled again without it. I spent 20 years in this mask. I wrestled Gorgeous George, I wrestled in front of millions of people in Japan, I went on *Regis Philbin*, and I was a three-time WWA world champion. This mask is just about everything to me.

~ Dick Beyer (The Destroyer), WWA World Heavyweight Champion; founder, Destroyer Park Golf; Akron, NY

Who appeared on the second-highest-rated TV show in Japanese history? That would be The Destroyer, who wrestled Japan's reigning champion in 1973; 70 million viewers tuned in.

"Think of all the hands THAT HAVE TOUCHED THIS OBJECT."

My family has lived on Cumberland Island for seven generations. There are no paved roads, no stores. Only 38 of us live here. One of my favorite things to do is walk the tide line looking for treasures. I've found a 25-pound woolly mammoth molar, alligator skulls, a camel's tooth, rattlesnake ribs, thousands of things, but when I found this petrified shark's tooth, I could not put it down. There's almost an electricity that runs between you and the tooth. The tooth is millions of years old, and it was millions of years old before the Timucua Indians, who once occupied the island, made it into an arrowhead. After they'd used it as a weapon, they drilled it and used it as adornment. Which is also how I use it. I'm fascinated by this overlay of history—think of all the hands that have touched this object. And one day it will pass through my hands and into my daughter's.

~ **Gogo Ferguson,** jewelry designer, Cumberland Island, GA

In the corner of our guest room I have a tanpura, still in its case, never played.

I grew up in Montreal, and the Bengali community there was really small, like seven kids. On Sundays, we'd get together and sing Bengali songs and do little dramas and dance. My mother was known for her singing and could play the sitar, tabla, harmonium. She could play *anything*. People would bring their instruments for her to play, but she never had any of her own.

Years later, my dad traveled to India and brought back this tanpura to surprise her. It's beautiful: 5 feet high and made of dark wood. He got it engraved; on the lower-right side it

"MY DAD BROUGHT THIS BACK TO SURPRISE HER."

says, "To my darling Shantona" and the date. He was so happy to give it to her.

Within weeks of his return, my mother was diagnosed with cancer and she passed away not long after. She was 51. She never got to play her tanpura or even hold it. The case still had the luggage tag on it.

My parents were very conservative, and I never saw them share affection; they never said, "I love you," but I know they really loved each other. My dad passed away last January, and now the instrument is with me. When I look at the tanpura there in the corner, it's . . . complicated. It reminds me of my mother and of my mother getting sick but also of my father coming home from the airport, so excited to give it to her, and of the love he had for her.

~ **Sonali Roy Son,** data scientist, Snapchat; Santa Monica, CA

"I'D ALWAYS LIKED TO BE AROUND THE GUYS WHO WERE GOOD AT FIGHTING FIRES."

You never come empty-handed to a firehouse. So when I got relieved at 8:30 that morning, I stopped by Dunkin' Donuts before heading to the 252 in Bushwick, my old firehouse. The night before, my friend told me he'd gotten engaged, so I was going over to congratulate him in person. As I pulled up, they were heading out the door, all of those guys. The second plane must have just hit. I was in flip-flops and shorts. They told me what happened, and then they were on the truck and gone. I shut the door for them. All of those guys died, including my friend.

The whole thing had such a huge effect on me and on my life. I lost a ton of friends, and my whole world changed. I guess it changed for everybody. I'd always liked to be around the guys who were good at fighting fires, but this threw me into a different realm. Like, it cemented it as part of my identity. A lot of firemen got tattoos to remember 9/11. My wife didn't want me to get one. So I ended up using a small piece of steel from when I was working at Ground Zero in the months after—along with the gold from my father's wedding ring—to make this. I wear it around my neck. The "343," that's the number of firefighters who died that day.

I had a difficult relationship with my father at times, but, you know, he was a person of integrity. His integrity . . . and the firefighters' commitment and sacrifice . . . the pride they took in their work . . . it just gives me something to aspire to, a reminder of what others have done. It's weird to talk about it, even now. The feelings were so amorphous, just floating around. Maybe after I wear it the rest of my life, I'll have a better idea of what it means to me.

~ **Larry Tompkins,** captain (retired), New York City Fire Department, New York, NY

My grandfather was the mayor of Sifsafeh, a village in Syria about 15 minutes from the Mediterranean. This meant people were always coming to his house so that he could solve their problems. And that meant my grandmother was always cooking, often with this *meklee*. All the other children were playing but I would watch my grandmother cook. She got this pot from her mother, so it's at least 150 years old. It sat on three stones above a fire, and I remember the smells: the wood burning, the sautéed onions, the spices.

I went to college in Damascus, then to America for a master's in food and nutrition. Before I opened my restaurant, I asked my mother for my grandmother's pot. My mother came to visit and wrapped the *meklee* really well—it's big, about 15 inches across—but in the Minneapolis airport, a customs officer cracked it. My heart broke. The pot is made from a kind of stone, and it's thick, which is why the flavor is so good. They don't make these anymore. I'm looking for an old person in Syria who knows how to fix it.

~ **Sanaa Abourezk,** owner, Sanaa's 8th Street Gourmet, Sioux Falls, SD

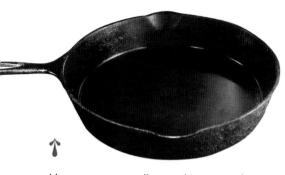

My momma was divorced in 1949 when I was only six years old. We were in the midlands of South Carolina, in a small rural town that was religious in its outlook. Divorce was unheard of. My grandmother had a great hand in my upbringing, an original steel magnolia, presiding over the dinner table and running a tight ship. Her yard was a paint box of colorful flowers. From the upstairs bedrooms, where I slept, you could smell coffee and bacon and maybe liver pudding wafting up the stairs.

This skillet belonged to her. It's in the anvil category, made of dense iron, and it will rust in a heartbeat if you don't take care of it. I use it two or three times a week, for everything from making stews and okra and Limpin' Susan to frying bacon—bacon being one of the three essential food groups, the other two being butter and bourbon. I never put the skillet in the cabinet, and it was equally a fixture on top of her stove. I know she had it for close to 50 years, and I've had it for 50 years after that.

I live in a huge old house that's loaded with stuff from all over the world. It's all pretty to look at and ornaments our lives, but it doesn't evoke the memories that this old pan does sitting there on the stove.

~ **Benjamin McCutchen Moïse,** retired game warden and cook, Charleston, SC

I love decorating and cooking so much that at work they call me the black Martha Stewart. Breads, cakes, cookies, cobblers—I bake because it brings people together, puts a smile on their face. I've had this same KitchenAid for 20 years. Back in the day, it was top-of-the-line, and it still sits on my counter because I use it all the time. At work, I'm on the line assembling doors. The way I look at it, every car is *my* car, and I want it done right the first time. I don't want it to come back to me. And cooking is basically the same thing.

~ **Clarice Williams,** utility associate on the door line, Ford Motor Company, Romulus, MI

"I bake because it brings people together."

"The troops had to leave the wounded behind."

All those years I toured with the Allmans, I kept a Xerox of this letter in my suitcase. I never showed it to the guys, but I looked at it when I was feeling low—or too big for my britches. It was sent to my mother by a prisoner of war, a private, who was with my father in his last days, and it describes the conditions and my father's passing. It speaks to courage and to the futility of war, and after all these years I can't read it without getting choked up.

The war was supposed to be over by Christmas of '44, but the Germans attacked. My father was in Belgium, and his unit was called to the front. This was the Battle of the Bulge. He was hit by shrapnel and his unit got overrun, and the troops had to leave the wounded behind. My father was captured by the Germans. The letter describes how he was cared for by some nuns and a Polish doctor but also that there was no penicillin. There's one line that stands out for me: "He gave me a picture of you and a ring which he told me to see that you get . . . That afternoon at 2:20

he passed away, and in his passing I knew the nation had lost a good and brave man."

I was five at the time, and I don't remember much. My mother had sent a Christmas package to my dad that year. It came back unopened, and I remember that I was excited because it had Hershey's bars in it. I didn't get that it was a package my father never received. When I read the letter now, I feel a great sense of pain for, you know, the thousands and thousands of men who were dying so far from home and who had those thoughts that they wouldn't see their wives and families again.

The soldier who wrote the letter, Charles Peterson, lived in Tennessee and he eventually came to our home and brought the possessions, but over the years we lost contact.

~ Willie Perkins, road manager, the Allman Brothers Band (1970–76), Macon, GA

England
April 23, 1945

Mrs. Wm. H. Perkins:
Dear Mrs. Perkins:

I should have done this before now, but due to being a prisoner of war in Germany from the 18th. of December until the 26th. of March, I was only allowed to write home twice and these two times I wrote to my wife. And now I doubt if she ever got them.

Now, I will try to tell you what I started to. Capt. Wm. H. Perkins was wounded Dec 19th in the Bulge near St. Vith, Belgium, by German artillery. His left leg being wounded above the knee. The Germans were making a push. American Medical men got to him and gave him first aid, and got him back to an aid station. There they had to amputate his leg. This being done by an American Major. Sometime during the night the Americans had to retreat. The aid men and badly wounded remained there and were captured by the Germans which started to moving them further back into Germany. At the same time they would stop at aid stations which was about four or five. Then on Dec 23rd. he was moved to Nuaweed, Germany. There is where I first met the Capt. "And then I knew he was a brave man." That was in the afternoon. The hospital we were brought to was a military one. There were eight Americans and the rest were Germans. We were there until Jan 3rd., being bombed out by American planes. We were moved to another Stalag which were filled with every kind of race you could think of. It was a dirty hole but lucky for us they had a Polish doctor who could speak English and was a good doctor. He gave the Captain the best care he could with what he had. The other men were good to him, giving him cigarettes, something we never had before. We stayed there until the seventh of January and were moved to a Catholic hospital in Montabeur, Germany. I was lucky, I went with the Captain,— five of us. The Polish doctor arranged this for us, and it was really better but the Captain was too weak to be moved., and the way he had been moved the other times were no good either. I think that infection had already set in before we left the rest camp. Thats what they called it, but I wouldn't. The Polish doctor was giving him shots for infection. It wasn't pennicillin, because the Germans don't have it. We arrived at the Catholic hospital on Sunday afternoon. There they re-dressed our wounds and gave us nice clean room, also brought us some nice hot soup. The Sisters were very good to us during our time there but the Captain got worse every day. He never complained much, and the worse trouble we had was making them understand what we wanted. After we got to the hospital the Captain's leg began to swell. Then the swelling started up his side and kept going up until it finally reached his heart. That was on Jan 15th. That morning one of the Sisters made me understand that the Captain wouldn't live through the day, and would he want a Protestant preacher or a Catholic father. So I told her Protestant. He came about 11 A. M. He could speak a little English, so he read to him the 11th to the 16th versed of St. John, 10th chapter. After he left the Captain called me over to him and gave me his watch. Also he gave another fellow his fountain pen. He gave me a picture of you and a ring which he told me to see that you get. I have them now and as soon as I get back to the states I shall send them to you. All his money, pictures and other valuables were taken from him by the Germans. That afternoon at 2:20 he passed away, and in his passing I knew the nation had lost a good and brave man. He had more courage than any one I have ever seen and I have more faith in him than anyone I'd ever known in that short time. I haven't tried to spare you any because I felt you would want to know. The Captain was buried Jan 18th in Montabaur cemetery. Four of us were allowed to go to the funeral. Also they had French prisoners of war. Soldiers held a little military ceremonies at the grave and the father lead us in prayer. He was buried in a nice wooden casket with wreaths made out of pine boughs with red flowers. The Sisters made that for him. I guess Mrs. Perkins that's about all I can tell you. My home is in Paris, Tenn. I think I'll be heading home soon. I am in the hospital now so if you want to answer this my address at home is 1027 West Depot St. Paris, Tenn. If you have a hard time reading this forgive me for I haven't had use of my right arm only two days as it has always been in a cast - since Jan 10th. In closing Mrs. Perkins I send you my wishes for much happiness in the buture. God bless you and your children.

I am your friend

Pvt. Charles W. Peterson

"I'm a religious mutt."

Inside this little box there's a rosary and a miniature Koran. I keep the box on my bedside table and while I don't open it that often, I see it every day. When I had pneumonia a few years ago and almost died, I had it by my side. It gave me peace.

My father is Jewish, but I've had this Koran since the day I was born. My mother, who was raised among devout Lebanese Muslims outside of Detroit, safety-pinned it to my pillow to ward off evil spirits. In my late 20s, I secretly converted to Catholicism and was considering going into the priesthood. That's when I got the rosary. But I still kept the Koran pinned to my pillow.

I really am a religious mutt, a Lebanese Jew who grew up as a Muslim and converted to Catholicism. These two artifacts remind me of my place in the cosmos. I would never separate them because they represent a continuum of faith that runs throughout my life—and *of course* they should exist side by side, just as the world's religions should.

~ **Lindsay Bierman,** chancellor, University of North Carolina School of the Arts, Winston-Salem, NC

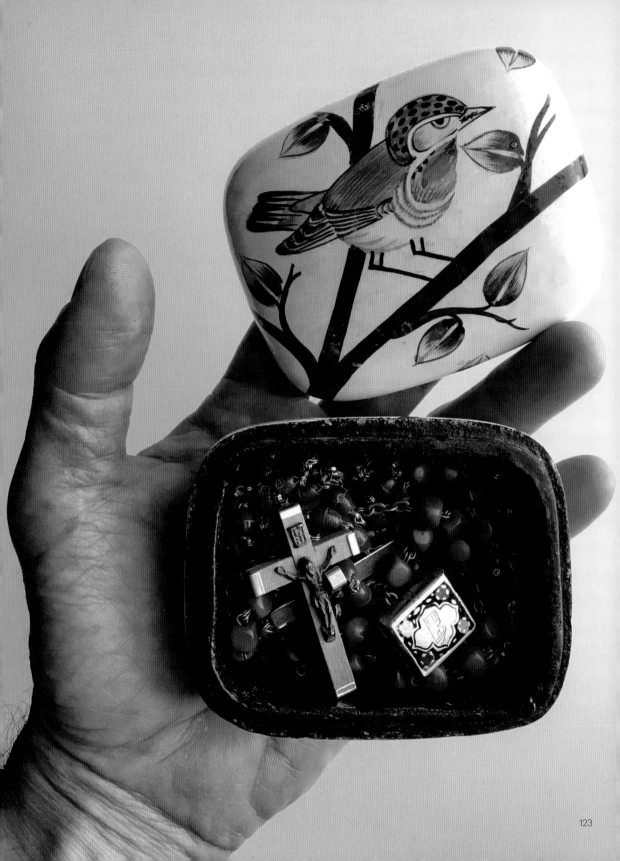

"She's an unexpected feminist."

I'm completely obsessed with Dolly Parton and have been for a very long time. Her voice, it really gets me. If I listen to *Little Sparrow* in the dark I might start crying, even if I'm totally sober. She's sort of the redneck John Lennon, and coming from Mississippi, as I do, I really relate to that, to someone from a small place, from such meager means, someone that people would mock. And yet all she's done is preach love and open-mindedness.

She's an unexpected and unusual feminist. So when I saw this in a junk shop in Nashville, I got heart palpitations. It's carved out of a hunk of wood and I would have gone into the thousands for it, but it was $150. It hangs on my wall and makes me feel connected to the South—and I also pat myself on the back and say, "Fuck, yeah. You're a good thrift shopper!"

~ **Sarah Gray Miller,** editor in chief, *Modern Farmer*; Athens, NY

"It's a little magical."

One of the real treasured things I have up in my office is a photograph of President Clinton getting off a helicopter from Camp David with one of my books under his arm. The picture ran in thousands of papers all over the country. One of my friends actually saw it and sent it to me and then I kinda tracked it down.

That was the beginning of a relationship, long distance at first, but then President Clinton was down here in Florida and we spent a couple of hours together, just two humans shooting the breeze—with the Secret Service peeking in every 20 minutes or so. Now we're writing a novel together. Bill is a big mystery-suspense-thriller fan, and it's been the highlight of my writing career. I'm older than 40, and it's kinda cool to have highlights, you know, later in your career.

I grew up in a small town in upstate New York—Newburgh, New York—tough little town. My father grew up in the Newburgh poorhouse and his mother was a charwoman. He was bright—he wound up going to Hamilton, a good college—but he didn't have lots of confidence and he drove a bread truck for 11 years. It's a long way from that to writing a book with the president. It's wonderful. It's a little magical. It's a smile, that's what it is. I wouldn't have expected it. And that picture started it all. I'm staring at it, even as we talk.

~ **James Patterson,** author of the most No. 1 novels on the *New York Times* best-seller list, Palm Beach, FL

"There must be different ways to think about healing."

When I finished medical school in Johannesburg, I went to work in the bush. As a young white doctor in South Africa—this was in '81 or '82—you could either go into the army or work in the "homelands," designated areas where the apartheid government had placed specific tribes. Most guys I knew chose the army; I went into the homelands.

I was living with various tribes and traveling to these extremely rural areas, seeing things that white people never ever saw. In one village, I got friendly with a traditional healer who lived down the road from the clinic. In medical school, we'd been taught that traditional healing was quackery, but there were patients we couldn't help at the clinic and I would later see them at the healer—and some of these patients got better. This made me realize that there must be more than what I learned in school and different ways to think about healing.

The Ndebele tribe, with whom I spent a lot of time, make these beautiful beaded patterns on goatskin and I grew intrigued by them. This one hangs in my living room and brings me back to that time in my life, a very introspective time, I guess, that became so influential in my thinking. It opened my eyes and, in many ways, changed the way I approached medicine and so many other things.

~ Frank Lipman, physician and acupuncturist, specializing in integrative medicine; founder, Eleven Eleven Wellness Center; New York, NY

"WHEN SOMEONE DIES,
you look at the things they
touched in a new way."

A few weeks into my senior year of high school, I was miserable, so I called my brother in Boston. Bob was six years older than me, and he told me I could move in with him if I paid for rent and food. This was '73 or '74 and I lived with him and his wife, Louise, for about six months before I found my own place.

I was very close with my brother, but we never exchanged gifts. He was on dialysis and pretty broke, and it just wasn't something we did. But on the night of my 20th birthday, he and Louise had made me a cake and had wrapped up a gift.

It was a mirror. This was a big deal. I was just starting to think about becoming a hairdresser, so it was a really thoughtful gift. It's been with me for 40 years, through relationships, through moves, through cities. It's amazing that it survived.

When someone dies, you look at the things they touched in a new way. My brother was my touchstone; he remembered my past as I did. I was at his side when he died, and I felt privileged to go through that process with him. Every time I look at the mirror, I have a moment.

~ Skipper Silberberg-Edwards, hairdresser, Orleans, MA

"EVERYONE ON EARTH IS LOOKING FOR THAT FEELING LIKE, AHHH, THAT WAS A GREAT DAY."

Every Sunday, we'd all put on nice clothes and go to this little church out in the country, out in Salem, Ohio. I was a kid, and when I'd get too fidgety, my grandmother would open her purse, and this whiff of Beemans gum would come out of it, and then she'd pull out this tin cup and send me to get a drink of water. My grandfather had brought the cup home from the war. I'd be like, "Excuse me, excuse me, excuse me," and make my way to the little drinking fountain down in the basement of the church. I remember being fascinated by the cup because it could collapse but could also hold water.

When my grandmother died, my mom asked me if there was anything I wanted, and I said, "Does she have the cup?" Sure enough,

it was still in her purse. She'd carried it there since the end of the war.

I keep it on my sink. It's sturdy—most things in that era were heavier than they had to be—and it even has its own taste when the rim hits your lips. Seeing that cup every morning brings me back to simpler times, when your parents handled things and you just had to go ride a Big Wheel. At night, everyone on Earth is looking for that feeling like, *Ahhh, that was a great day.* There are many paths to that. I tried drinking, cocaine, women, all of that. Then I found mountain biking. Every day there's this cup on my sink that says, "Go out and build a tree fort, go ride your bike."

~ **Ray Petro,** founder, Ray's MTB Indoor Mountain Bike Park, Cleveland, OH

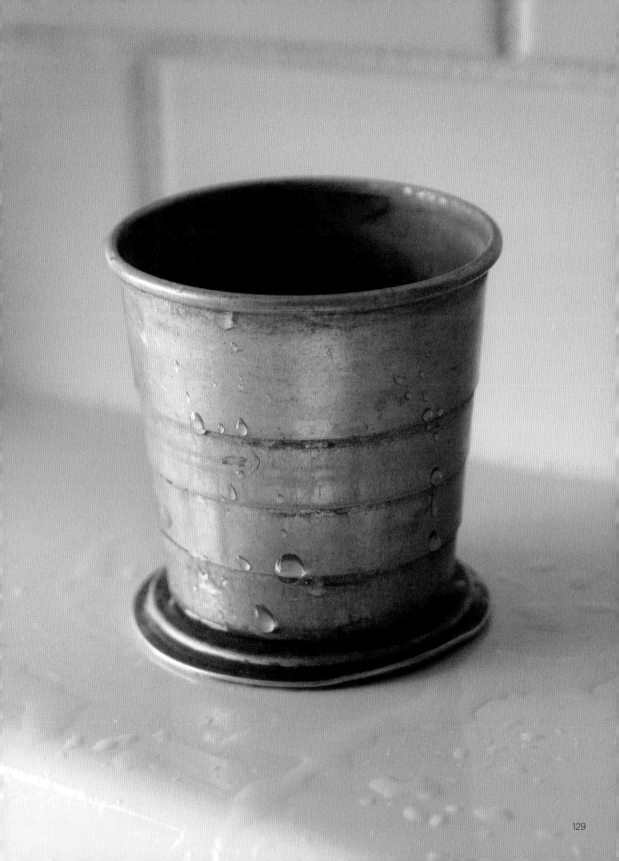

"WATCH WHAT'S HAPPENING AND ASK A LOT OF QUESTIONS."

This diary was given to me by my mother. When I got it, I felt like an adult, like a rock star. It's shiny, with pink pages and a lock, and I felt like I was entrusted with this thing that I got to put my own words in. It was my domain.

The diary is important to me not because of what I wrote in it when I was eight years old but because of the instructions that came with it. My mother told me: "Start every morning reading something new. Spend part of your day, every day, watching and listening to people. Always ask questions, even when you think you know the answers. Also ask *yourself* questions, even when you think you know the answers. Now, reflect on what you see, what you learn, and what connections you're making. Write them all down here."

So that's what I did.

"Watch what's happening and ask a lot of questions" was sort of the motto of our family. You could say it was lifelong training for what I used to do as a journalist, what I do now as a futurist, and how I try to live as a person.

~ **Amy Webb,** author and futurist; founder, the Future Today Institute, a future forecasting and strategy firm; New York, NY

"IT WAS TOUCHED BY

WEIRDNESS."

Me and my best friend were walking to the mall in junior high and this just crazy, crazy guy runs by, stops, and stares at us for, like, a long two seconds. Then he shoves this watch at us like it's the most important thing. He never says a word. Just hands it to us and zooms off. It was so random. It didn't have cooties, exactly, but it was touched by weirdness. And without ever talking about it, we starting passing it back and forth. I'd hide it in her gym bag and then eight months after that, I'd find it in my locker. It's gone like that for decades. Inside a sleeping bag. In the back of the freezer. In a suitcase bound for Ireland. Every time I find it, it's like a gift from the past.

~ **Kerry,** graphic designer, Toledo, OH

"I WENT TO A COMIC CONVENTION, STOOD IN LINE WITH FELLOW GEEKS."

As far back as I can remember, I wanted to be a comic book artist. I drew all the time—sketches in notepads, panel work. Hundreds and hundreds of hours. My high school yearbook said, "Most likely to be a Marvel comic book artist." After I graduated from college, I even went to a comic convention, stood in line with a bunch of fellow geeks, and showed a Marvel editor my work. He not only liked it but invited me to the Marvel offices and gave me an assignment.

I drew the Punisher and Black Widow leaping from a window. A full page. They liked what I turned in and accepted it. Then I waited for it to come out. Weeks went by. I went to the comic book shop every Tuesday, but nothing. I was beyond disappointed, because it's not enough to *sell* the art; you need to be able to *hold* it for it to be real. I never heard from them, and I was young and hadn't yet learned to be persistent. So it was a dream not really fulfilled, and I always regretted that.

We were in a recession at the time, and I'd been working construction and delivering Chinese food to make ends meet. I was also starting a salsa business and eventually that took off, which led to an MBA at Wharton, fixed-income sales at Goldman Sachs, a career in business, and . . . life.

A couple of years ago—and this is almost 25 years after I sent in my Punisher drawing—I had an offhand conversation with a co-worker, which must have triggered something because the next morning I woke at 3:15, like a synapse snapped, and said out loud, "How do I know it never ran?" I grabbed my iPad, did a quick search, and a link showed up. I couldn't believe it: My drawing had been published in 1993—more than a year after I'd stopped checking. Tears came to my eyes.

It actually changed my perception of myself because for all those years, I'd thought I hadn't succeeded at this pursuit that had mattered so much to me—this lifelong dream, this thing I'd worked so hard to do. And to think I might never have known.

~ **Sean McDuffy,** partner, investment management firm, New York, NY

"I DON'T HAVE THAT MANY FIRSTHAND MEMORIES OF HIM."

I have a clear plastic binder that holds the remarks that were made at my father's funeral. There's the reverend's sermon and the things that my aunts and uncles said, people he worked with, friends. I was 10 when my father died and I don't have that many firsthand memories of him—and it's kind of hard to tell at this point what are actual memories and what I came to learn afterward, what I, you know, pulled together.

Because of my job, I've gotten pretty used to telling the story of how he died—he was shot in the back by a 16-year-old with a stolen gun while on a business trip in San Francisco—and it doesn't affect me emotionally anymore. But reading these remarks and hearing what a good guy he was still hits pretty hard. That's when I feel that sense of loss of not having had a guy like that in my life to help me navigate becoming an adult. The binder . . . I don't read through it that often. I don't want to become numb to what's inside.

~ Ian Johnstone, founder, Gun by Gun, a non-profit working to prevent gun violence; Venice, CA

In Memory of

DAVID ELLIOTT JOHNSTONE

1948 - 1992

by The Rev. John Buehrens -- Presiding minister, long-time friend of David and Teena in Dallas, currently co-minister of The Unitarian Church of All Souls in Manhattan

David was shot in the back just a month ago today. On the streets of San Francisco, where he had gone as an editor to meet with some new authors. On Nob Hill, on his way back from a restaurant to his hotel, just as he had done the night before. Shot by some teenagers, out robbing tourists.

He survived that attack. Just barely. With his spinal cord severed. Two weeks ago Tuesday he was brought by MedEvac back here to New York. He was paralyzed from the waist down, and facing life in a wheelchair. Yet he had much to live for, and knew it. Shortly after he entered Rusk Institute for rehabilitation, he was visited by a staff psychologist. Later he reported on the interview to Teena. When she called me on Monday, just hours after a blood clot formed in his leg had taken David's life, she told me about it.

The psychologist must have inquired about anger. David reported that he felt no desire for revenge, little if any hatred toward the young men who'd shot him. As though he were worried: should he feel more angry? Would that be helpful? No,

In 1984 my brother and I got to be seat fillers at the Academy Awards. I was a year out of college, working in a lab, and debating whether I should go to film school or medical school. We're in our tuxedos, waiting in the seat-filler line, when we get tapped and go sit for five minutes. The real seat holders come back and I say to my brother, "You know, we're young, good-looking guys. We're in tuxedos. No one knows we're not Hollywood stars. Let's just hang out in back." This is totally against the rules, and we could have gotten kicked out, but we do it—until the Deputy Seat Filler spies us, berates us, and then seats us somewhere else, not far from Jack Nicholson and Shirley MacLaine and Michael Caine. We sat there for the rest of the show.

I later went on to run the army's lead institute that conducts research on bioweapon threats, like Ebola and anthrax—you know, like Dustin Hoffman in *Outbreak*—but this Oscar program takes me back to a time before I was channeled into any specific career, to a night of youth and glamour and the freedom to do whatever you wanted. Why do I keep this? The dreamer in me holds out this crazy notion that someday I'll actually win an Academy Award, and from that stage I'd be able to say to all the young people, "I was once a lowly seat filler, and you can make it up here, too. Here's the program to prove it."

~ **Mark G. Kortepeter,** expert in biodefense and highly hazardous infectious diseases; professor of epidemiology, University of Nebraska's College of Public Health; Omaha, NE, and Potomac, MD

When I got out of the service, I moved to Lincoln, Nebraska, and lived with two other guys. I was still young and unsettled, and it was a dirty period with a lot of drinking going on. But when I had my kids, something changed in me. It was at that time that I started carrying this in my wallet, and it's been there ever since. It's a copy of my DD214 discharge papers from the army. It reminded me of the structure my life had had in the service, and I was able to put that structure into my life. Everything changed after that.

~ **Gary Ratzlaff,** mayor, Red Cloud, NE

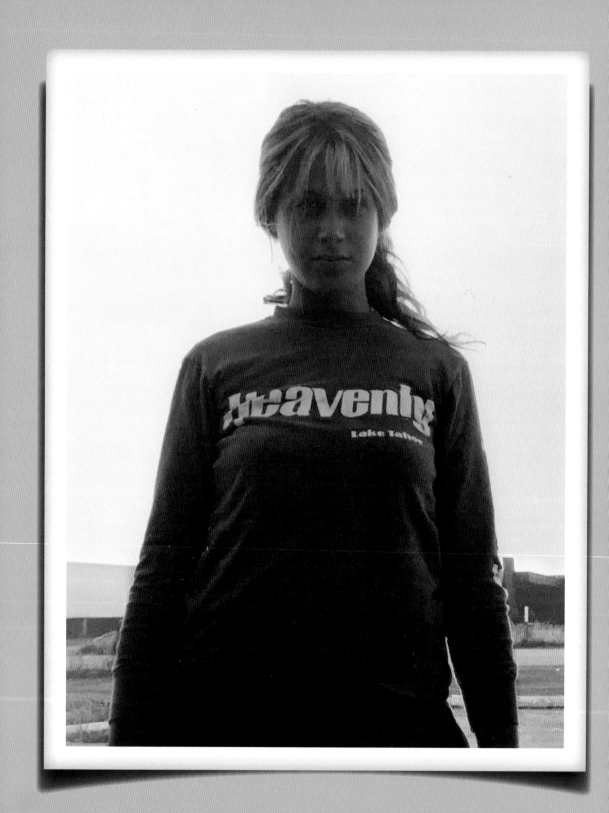

"Beauty and sadness, fashion and hope, and Dennis."

I got this T-shirt in 1995. It's the perfect shirt. Bright blue, vintage, and it says HEAVENLY LAKE TAHOE in white letters. When I look at the shirt, I see a whole lifetime, a million lifetimes. I see beauty and sadness, fashion and hope, and Dennis.

I bought it at a store on Melrose, in L.A., when I was trying to make it as a model and working next door as a hostess. I had two lives then: I was following Phish around, selling ganja goo balls in the parking lot, and also running wild in New York's fashion scene. The shirt translated to both worlds. I used to wear it with maroon pants from the Salvation Army and Nikes. My life was a mess then but when I was in that outfit, in that shirt, I felt like I was keeping it all together.

That summer I was living in L.A. with my best friends, Oona and Dennis. Dennis loved the shirt and wore it all the time. That was a long time ago. It's been 11 years since Dennis committed suicide. I wore the shirt to shreds, until one arm fell off, but I saved it.

One morning a few years after his death, I knew I was finally ready to say goodbye to him. I woke up early and decided that I was going to throw the shirt in the East River. But when I got to the river, I couldn't do it. I couldn't say goodbye to it. I loved that shirt. Even if I found the same shirt online, even if it fit like a glove, it wouldn't be the same because I want Dennis back.

~ Molly Rosen Guy, co-founder and creative director, Stone Fox Bride; Brooklyn, NY

"Pawpaw's seeds were still in the freezer."

My grandfather lived in a tiny town called Saks, near Anniston, Alabama. He worked a blue-collar job in a textile mill and wore overalls. He was always whittling something. I'd visit in the summers and watch him in the garden. He planted birdhouse gourds that he'd turn into homes for purple martins, which he loved. Some years after he passed, I brought my wife to see his homeplace, which my uncle looks after now. We got to talking about seeds and my uncle mentioned that Pawpaw's seeds were still in the freezer. We opened it and there they were: white, threadbare pillow sacks with Pawpaw's writing on them. He couldn't read, so there were a few misspelled words. I took some corn, bean, and gourd seeds. They must have been in that freezer for 25 years.

I planted the seeds the following season. I don't know how to put it into words, but when I'm in the garden with those gourds I feel the connection to my grandfather, like we're working together.

~ **David Shaddix,** owner, Maple Valley Nursery, Sterrett, AL

"We called my grandmother Madear; everyone else called her Miss Honey."

I grew up in Memphis with a single mother and a grandmother who lived across the street. We called my grandmother Madear; everyone else called her Miss Honey. She and I spent a lot of time together. She took me to church where I learned the bible front to back, and she

dragged me with her when she visited the sick and the shut-ins. She was a central figure to me.

About the time I was nine, there was a pivotal moment: My grandmother's sister passed away, and right after the funeral my grandmother went to her room for a long time. When she came out, we talked for a moment and she handed me an Eisenhower dollar, then went back to her room. It was the last lucid conversation I had with her. Something changed; she was okay one day and the next day she wasn't. She was never clear of mind again, and that dollar was the last gift she gave me.

She is definitely with me on my path. In junior high biology, we learned about genetics. Right then I wanted to be a geneticist. I remember thinking, *If I can do this then I can figure out how I can help my grandmother, and then I can have a conversation with her again*. So I focused on math and science. My grandmother also planted the seeds of my social-impact work. I feel her spirit in everything I do—and this Eisenhower dollar has been with me the whole way.

~ **Kimberly Bryant,** founder and CEO, Black Girls Code, Oakland, CA

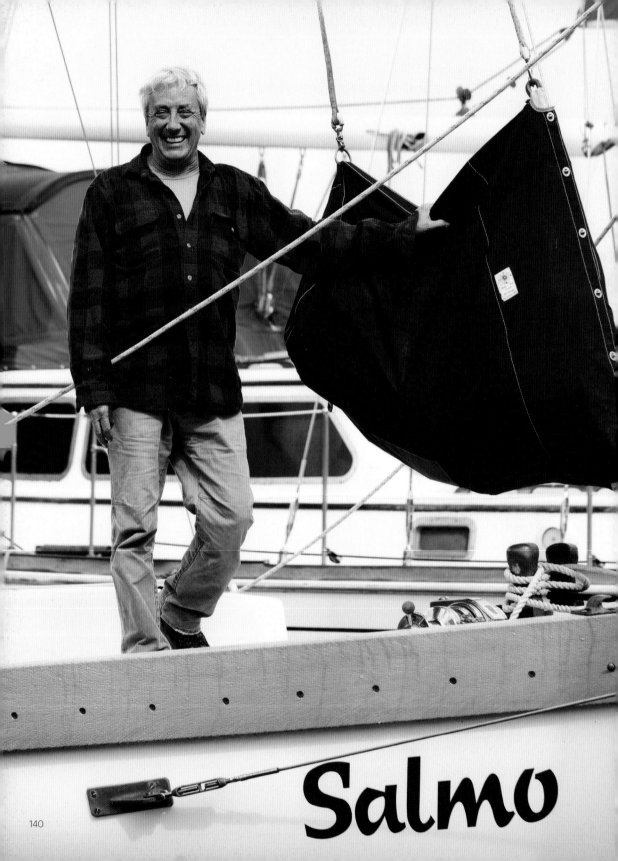

Salmo

"THERE WAS A GUY A COUPLE CELLS DOWN WHO HAD A SUBSCRIPTION TO A SAILING MAGAZINE."

Dude, my sailboat. It's a very special boat, a very robust boat, a rescue boat, an expedition boat that will go anywhere in the world. Only 15 of them were made.

I didn't grow up sailing. I picked it up in '86 while I was in federal prison for growing marijuana. There was a guy a couple cells down who had a subscription to a sailing magazine and I read it cover to cover every month. I started reading everything I could about boats and the lifestyle and the whole nine yards. I'm in prison, locked in a small cell, so the idea of having the freedom to sail? That was appealing.

When I came out, I had lost my family and my housing—my whole life had turned upside down—and it was a perfect time to create John as John wanted to be. For the first time in my life, I could say, "This is what *I* want to do."

And what I wanted to do was sail. I purchased a small sailboat and lived on it. After living in a cell, a boat is not hard to adjust to.

Today, I'm growing marijuana professionally. I get paid a shitload for something they once put me in jail for. I'm an operations manager, overseeing 23 people, from the growing to the selling to the marketing, HR, and payroll. I've got two years till retirement, till Social Security kicks in. Then I bail. I'm going to circumnavigate the planet, solo. There's no place you can be freer on this planet than on a boat in the middle of the ocean. The beauty, the isolation, I can't even begin to describe.

~ John Angelo, operations manager, Smooth Sailing Ventures; Puget Sound, WA

"Salmo is the scientific name for salmon," Angelo says. "I named it this because in the Northwest, salmon's what kept the natives alive; it has a lot of spiritual meaning."

"I came to parenting reluctantly and full of doubts."

When my then-wife was pregnant with our daughter, the *MAD* guys threw me a shower on a Sunday afternoon. Bill Gaines, Al Jaffee, Dick DeBartolo, everyone was there, and Mort Drucker gave us a big stuffed bear. You know how there's always one thing a kid latches on to? For M.E.—my daughter—this was it. Big Bear went everywhere and he truly became part of the family. We put a pet tag on Big Bear because there'd be hell to pay if he ever got lost.

When M.E. was five or six, I told her the story of Reegee-Beegee, a stuffed dog I loved that my mother tossed when I was a kid. M.E. was in utter disbelief, and the next day at school she made me my very own Big Bear out of felt and craft paper. That was 20 years ago, and I've looked at it every day since.

I came to parenting reluctantly and full of doubts about finances and whether I was going to be a good father, and years later my marriage went south. But when I see this, it immediately takes me back to the greatest time of my life, to the moments you feel that little hand reaching up through yours, when you know you've given her a section of your heart that you didn't know you had.

~ **John Ficarra,** former editor in chief, *MAD* magazine; Staten Island, NY

"I spent long, hard nights trying to figure out how to be

A ROCK STAR *AND* A MOTHER."

I've had a crazy life with a lot of ups and downs, and I always met a pregnancy stick with fear and loathing. But when I got to the time of my life when I was ready to have a child, I was overjoyed and found myself looking at the stick over and over. It became a beautiful object.

I thought I'd save it. I thought I'd give it to my child and tell them that it was the start of our relationship. So I put the stick in an envelope with the name I was hoping to give the child if it was a girl. I taped it up on my apartment wall.

I'm a hardcore feminist, and the culture didn't really teach me much about motherhood—and nothing at all about the marriage of motherhood and musicianhood. Role models were few and far between; people just drop out. So I was scared, and I spent long, hard nights trying to figure out how to be a rock star *and* a mother. I've made it my personal mission not to drop out, and to include motherhood and my child in my art. And it's been totally fucking awesome. I highly recommend it.

~ **Amanda Palmer,** songwriter and author, Woodstock, NY

There was this guy, a very nice guy. I was in love with him. He's the kind of guy who doesn't wait for a special occasion to buy a gift. One day, around Thanksgiving, he calls me and says, "I bought something for you. I saw it and it made me think of you." About a month later, he gives me a big box. I unwrap it and it's a choo-choo train. A big set. Very expensive. It would take up the whole room. What do I do with this? Where would I put it? Was it a joke? I said, "You told me this thing reminded you of me? *A train set?!*" He had so much excitement in his face as he told me, "When I saw it, it brought me so much joy, and *you* bring me joy." The way he said this, it was so sweet. It just got into me. We broke up not that long ago, and the box is still sitting in my closet. I never opened it, but I'm not giving it away.

~ **Lena Shnayder,** blackjack dealer, Monte Carlo Casino, Las Vegas, NV

I lived out of this backpack for a year. It was hands-down the best time of my life. I traveled all over Colombia, Peru, Bolivia, Argentina, and met a lot of people—oh my god, there was Ben, Marco, Tomás, Raj, and I think one other guy. But in the end it was just me and the backpack.

~ **Anonymous,** sous chef, Chicago, IL

"I WAS THINKING OF BURNING IT IN
SOME KIND OF
RITUAL GOODBYE."

Some years ago, my mom sent me a box of my old things, and inside the box was my baby blanket. It's mass-produced, and even on the day it was bought it was unremarkable. Now it's ripped and resewn and completely schmutzy—essentially a rag.

I realize that it once had major significance for me, and I didn't want to dismiss that, but all these years later, I really didn't want it around. So I left it sitting on the floor near the front door for months because I was thinking of burning it or burying it in some kind of ritual goodbye.

Then, one day, a few weeks after I turned 52, it sort of called out to me and I picked it up. It felt so soft, and I had this immediate, visceral, sensory connection to it. I just started crying. I don't know exactly why. The feelings just came up. And the blanket comforted me in a deep, preverbal sense. It brought me back to being a little kid in a whole-body way. I was *there*. There are no photos of me as a baby with the blanket, but I do have a memory of sucking my thumb and something warm around me. I can't say it's this blanket, but all these years later, it did what it was supposed to do.

~ **Billy Conde Goldman,** artist and homemaker, Roseville, MN

"PROTECTING YOURSELF AND YOUR BROTHERS,

that's what really matters."

When I went through the Marine Scout Sniper School it was roughly three months, and every day they basically try to destroy you. Physically, mentally, no sleep, no food, nonstop, whatever they can do to get you to quit, to say, "I can't do this anymore, I want to leave." It's one of the most revered, renowned, and difficult schools in the United States military, and has one of the highest attrition rates.

Immediately after graduating, we deployed to Iraq. When you're out there for real, you're in an austere and hostile environment. You might be doing long-range reconnaissance or delivering precision fire to eliminate a specific threat; you might be doing things that cause people to lose their lives. In those moments, it really sinks in: Nothing else in life is that hard or that complicated. You understand why there's such a rigorous indoctrination: Protecting yourself and your brothers, *that's* what really matters. You have to know that the guys you're working with *will not quit*. And it all comes back to this HOG's tooth.

When you start your training, you're called a PIG, a professionally instructed gunman. If you graduate, you earn the title HOG, which means hunter of gunmen. That's when they give you your HOG's tooth, the projectile from a .308-caliber bullet you wear around your neck. It's the portion that penetrates your target. They say the tooth represents the bullet that was destined for you, but since it's around *your* neck, you're in control of your destiny. You're safe.

I earned mine in 2005, and it's been off my body maybe three times. I wear it under my clothing. I could care less if anyone knows I have it. It's for me and me alone. Any time I meet adversity or something I'm not expecting, that's basically what I go back to. It's a reminder that whatever I'm facing now is pretty insignificant compared to other things I've dealt with.

I will never stop wearing my HOG's tooth: I could be working at Lowe's or working for a Fortune 500 company behind a desk and I will still wear it. I will never not wear it.

~ **Marshall Bowen,** private security and high-threat protection for U.S. government officials in the Middle East; owner, .308 Ghillies, a firearms retailer; Philip, SD

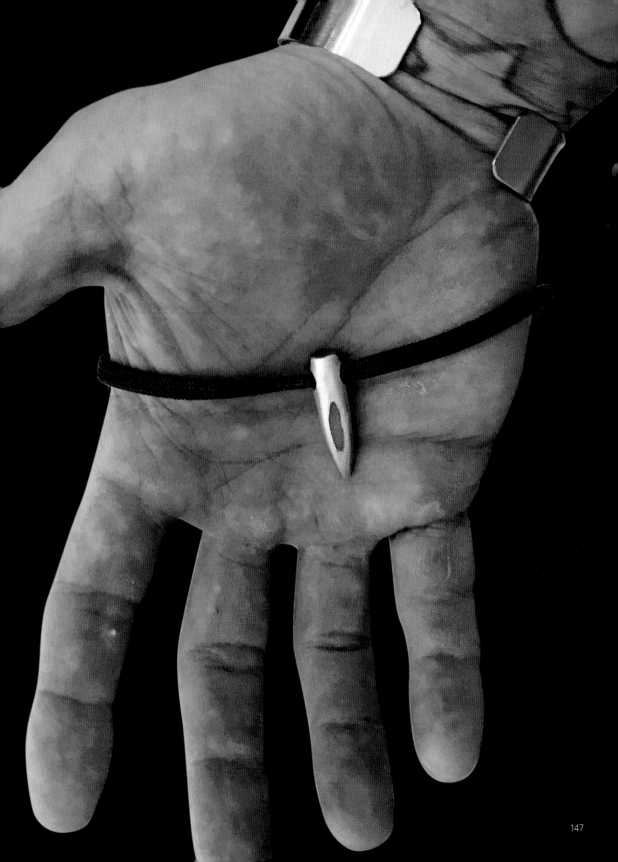

"I HAVE THE PRIVILEGE OF SEEING SO MANY THINGS
MY GRANDMOTHER NEVER GOT TO SEE."

I don't really have an attachment to objects. I don't like clutter. Stuff stresses me out. The things I hold on to are my memories and my stories and adventures. But when these bangles came into my life, they were so tied to my history and to the woman I am today that they're more than objects for me. They belonged to my grandmother who lived in Udupi, India. I only saw her once a year, but we were very close. A lot of my family there would tell me I should think more about family and ritual and getting a husband. But my grandmother, who spent her life in the house taking care of family, always had praise for me, for my accomplishments in school and my career.

I wear them on my left wrist, and only take them off for airport security. They remind me that I have the privilege of seeing so many things for her, things she never got to see.

~ Anarghya Vardhana, venture capitalist, San Francisco, CA

"This picture has been a reminder that my teacher knows my heart."

I received this on my 24th birthday. At the time, I was living at the Madhyamaka Buddhist Centre in York, England, and was very much caught up in Tibetan Buddhism and its whole Shangri-la image. But I was becoming aware of some conflict between various Tibetan traditions; I was confused, questioning, and, in hindsight, perhaps experiencing some healthy disillusionment.

As it happened, I was going to see my teacher, Geshe Kelsang Gyatso, who had gone into three-year retreat in the wilds of Scotland. When I arrived, we sat down to tea and somehow through the course of our conversation,

just naturally, it felt like he was addressing a lot of the concerns I'd been having. Later, as we were about to leave, someone said, "Oh, it's Morten's birthday," and Geshe Kelsang jumped up, ran into his shrine room, and came back with a brown paper bag, which he handed to me. I pulled out this photograph and he said, "It's Buddha; it's all you need."

That kind of stayed with me, almost like a mantra.

For 30 years, this picture has been a visceral reminder that my teacher knows my heart—and of his encouragement to focus on the essence of Buddha's teachings and not on the conflicts *people* bring to it. But getting attached to the photograph would be a misunderstanding of its nature: An image of Buddha is simply a representation of an actual state of mind—enlightenment—that we all have the potential for. My intention with this, and with everything I have, is that sooner or later I'm going to give it on.

~ **Morten Clausen,** Eastern U.S. national spiritual director and resident teacher, Kadampa Meditation Center, New York, NY

"HE WAS THIS GUY WHO WAS REALLY COOL— AND WHO YOU WERE DEATHLY AFRAID OF."

I have a vinyl record from 1969 of a sermon my grandfather gave when he returned to Bastrop, Texas, where he was born. He was born in 1928 and back then most of the black folks there, including my grandfather, were descendants of slaves. He began preaching when he was 16 or 17, and when he first started he got paid in canned goods, but he went on to start what became one of the largest churches in the black community in Dallas, at least before megachurches.

I found the record in my grandmother's closet in 2012, when I was in business school. Her closet was this great archive: She hoarded all these old press clippings and church programs and photos—there were cassettes, but I'd never seen any vinyl. I've got 30 cousins, so there's a lot of clamoring for things, but I just said, "Hey, Granny, can I take this?" She was in a good mood that day, I suppose, because she gave it to me.

The album cover is fuchsia, which is strange, and it has white lettering that says "Community First Baptist Church, Dallas, Texas," which is the church he founded. The choir—the C.H. Gerald Inspirational Choir—is named after my grandfather, and in a great case of nepotism, the director is his second-oldest son. On the B-side, the name of the sermon is "A Crown in Lay-Away"—my grandfather was known for his weird sermon titles.

We always had to go to church, but I don't really remember hearing my grandfather preach in person. I remember more just hanging out with him. He'd take my cousin and me—we were, like, seven, eight, nine years old—to IHOP, and then after IHOP he'd take us to the Dollar Store and get us these cap guns, and he would always tell us about fighting in the war in Korea and about shooting people. We knew that in the imagination of a lot of people in the black community in Dallas, he was a huge, larger-than-life figure. But for us, he was this guy who was really cool—and who you were deathly afraid of.

For such a long time, it was illegal for black people in this country to read and write, so the black experience in America is largely an oral experience. And a lot of that came through the church, came through religion. So to have this recording of my grandfather at 41, at what became a sort of very prominent church that he had founded, and in the town where his family had lived all the way back to slavery, is incredibly moving.

~ **Casey Gerald,** author, *There Will Be No Miracles Here*, Austin, TX

doesn't ask about the game at all but says, "What did you do with the cat?" I tell her we called Oakland animal control. She says, "They're gonna kill that cat!" Next day, we pick up the cat and try to find a place for it at a shelter, but none of these facilities have any room.

When I worked for the A's, our owner was Walter Haas, the nicest rich man that ever lived. We named the cat Evie, after his wife. Because of Evie, we started ARF, the Animal Rescue Foundation, the next year. Besides people rescuing animals, we started doing animals rescuing people, and we've put companion animals with seniors, battered women, special-needs kids, and vets with PTS. And we recently celebrated our 37,000th adoption! Look, I get fired up about this—you have no idea.

"Play stops and the cat scampers into the Yankee bullpen."

As a manager, I've been in some historic games and witnessed unbelievable moments, but this story is so hokey that I've been accused of making it up. To that, I just say, "Run the tape."

It's 1990 and we're playing a nationally televised game against the Yankees in Oakland Coliseum. A feral-type cat runs into center field. Play stops and the cat scampers into the Yankee bullpen and then comes around to our side. I bluffed him into our dugout and we got him into our bathroom and called animal control. My wife calls right after the game,

Anyway, the moment when Evie ran onto the field? We actually have a photo of that right in the foundation. When you walk into the lobby, it's there for everybody to see.

~ **Tony La Russa,** Baseball Hall of Famer; three-time World Series–winning manager; co-founder, Animal Rescue Foundation (ARF); Walnut Creek, CA

➤ Full circle: Twenty-eight years after the photo of La Russa and the cat was taken, we tracked down the photographer, Jon McNally, who shot this picture of his original picture, which now hangs in ARF's lobby.

"THESE YOU HAD TO *EARN.*"

Every summer at Camp Flying Eagle you got a sash and on that sash you got awards—patches— for your accomplishments. Judo, karate, soccer, basketball, cricket. Waterskiing and canoeing and sailing. Running, nature, neatness, and, oh, man, writing letters home. These weren't like the participation trophies kids get today. These you had to *earn.* Honestly, the sash became the measuring stick of my own sense of growth and accomplishment; it gave me a foundation of confidence. The crazy thing is that when I talk to other former Flying Eagle campers today— middle-aged guys like me—they *all* remember the sashes. I can't adequately express how proud I was to have them, how much they mean to me.

~ **Mike Serr,** senior manager, Alexa Automotive Business Development; Ann Arbor, MI

"I was in prison for 34 years, and

I THOUGHT ABOUT THE HAT CONSTANTLY."

I saw the previews for *Billy Jack*—I think this was in '71—and there was a scene when he squares off with the deputy sheriff. Billy Jack's wearing a jean jacket and a black hat, and he says to the sheriff, "I'm going to take this right foot and I'm going to whop you on that side of your face. And there's not a damn thing you're gonna be able to do about it." At the time, I had the same attitude as Billy Jack did: *I don't put up with any bull*. And I thought, *I gotta get me a hat like that.*

It's black and made of felt, and there's a ring of Budweiser beer tabs, the old ones, around it. It's very well-worn. Having the hat gave me confidence to stand up for myself. I wore it every day until I went to prison.

I was in prison for 34 years, and I thought about the hat constantly. Many times when I wrote home, I asked them to make sure nothing happens to my hat. I was afraid someone would lose it. I told my cellie all about it; he said, "*I gotta see this hat!*"

On the day I was released, I walk out of prison and there's my family. The first thing in my hands was my son. And then the hat. My son knew how important it was to me. He had sealed it in a plastic bag and put it in the closet so it didn't get damaged. I haven't been without it since. The hat and me have been through a lot together.

I'm wearing it now.

~ Lewis "Jim" Fogle, Indiana, PA. Fogle served 34 years in prison for rape and murder until his conviction was vacated in 2015 after the Innocence Project discovered DNA evidence proving he didn't commit the crimes.

"Both soothing
and beautiful"

put things. Sort of decorate it. That's when I bought the first couple of cows. They were china, or porcelain-like. People would come to my office and see that I had cows, and after that the gifts started and never really stopped. The variety was amazing. One of them was a 3-foot-tall Holstein made of wood; the ears got knocked off of that one at some point.

Why cows? Over the years I've asked myself that same question. The violence I've witnessed, the racism, the inequality, the aftermath of lynchings—cows are the antithesis of that. They're quiet and good-natured. They do nothing but help mankind eat and drink and dress themselves. They'll never hurt you. But it's also that I came from a small town in Kansas, and I visited farms as a kid with my twin brother, Jim. When we first started going to this one particular farm, the farmers showed us how to milk the cows, and they would squirt the warm milk into our mouths.

This feeling about cows being both soothing and beautiful has always been there for me. And I make no attempt to disguise it. Something *comforting*. I guess that's the best word I can think of.

~ **Richard Stolley,** founding editor, *People* magazine; while at *Life* magazine, Stolley was the journalist who tracked down the "Zapruder film" of the John F. Kennedy assassination; Santa Fe, NM

I've lived in my house for 30 years, but it's getting too big for me now. I know that. I know I have to downsize. But when I look around, all I see are stories, a lifetime of memories—a knife from Jordan, a walking stick from Halifax—and so many are tied to my wife, who's no longer with us. Sometimes I look around and catch myself saying, "That's coming to my next home. That's gotta go."

One thing I know I'm going to take is my cricket paddle.

I remember I saw an announcement in the newspaper that said something like, "Do you play cricket? We're trying to get an American team together for the Maccabiah Games in Israel." The Maccabiah Games are like the Jewish Olympics. I'd played a little cricket in college, so I thought, *Sure. What the hell!?!*

At the opening ceremonies we marched into the stadium behind the American flag, with teams from South America, from Europe, everywhere. It was a spectacle. This was a big, big event in my life. It was 1973, and I was 40 years old, one of the oldest guys on the team. I knew it wasn't going to happen again for me.

We hadn't had much by way of practice and we lost every game. It didn't matter. I made it to Israel, played, met some great guys, the *New York Times* wrote about us. And I got this cricket bat. We each did. It's maybe 10 inches high, and we all signed each other's. This was literally half a lifetime ago. So much has happened since then. And so much never happened. It was a magical time in my life.

~ **Bernard Shapiro,** retired lawyer, Sherman Oaks, CA

"IT WAS A MAGICAL TIME IN MY LIFE."

"I DIDN'T KNOW THAT GOD HAD A DIFFERENT PLAN."

This altar, this chair, this church. I spent hours and hours here. This is where people first told me, starting when I was a boy, that I should become a pastor. But at the time my dream was to go to medical school. I didn't know that God had a different plan.

I grew up in a city called Kananga, in the Democratic Republic of the Congo. I went to college and majored in biology, but during the country's political and economic troubles, I couldn't afford to stay in school. So I decided to start a business, but the conditions made it impossible. I ended up losing everything. At one point, I met with a pastor from Nairobi and asked if he would pray for my business. He looked at me and said, "How long will you take to listen to God? If you don't listen to God, God will take you by force and put you in the ministry. But if you say *yes*, God will take you

beyond." It took me a few more years to say, "Yes, I will try."

Today, I'm a pastor in Le Mars, Iowa. The photograph my wife, Berth, and I are holding is of my home church in Kananga, one of the places we offered service during a missionary trip to Africa in 2013. Someone in our group took this picture—of the altar and the chair—without me even knowing, and they sent it to us as an anniversary present. The picture is very powerful. The words are very powerful: *For I know the plans I have for you.* It took me a long time, years of moving around, before I came back to the plan God gave to me.

~ Rev. Dr. Okitakoyi "Michel" Lundula,
United Methodist Church of Le Mars, Le Mars, IA

It was Christmastime and I was out at the cemetery managing a cremation while Becky and our daughters were at a friend's house. They saw the fire engines roaring by. We'd bought the house in the '70s, remodeled it a couple times, and now we stood there, with the bystanders, watching it burn. Our belongings were all over the lawn, trashed, burned, and melted. We'd lost everything.

I ran the cemetery for 23 years, and when you see someone bringing a child out there or a loved one of any sort, you see a real disaster. This fire might've *looked* like a disaster, but it was just a setback. Just a kick in the butt. They were just material things.

I've spent my career around stones. Been cutting headstones for 36 years, and now Becky and I have this rock shop. We sell thousands—gemstones, rocks, beautiful and strange ones. We get incredible rare fossils, and I don't get attached. But about a year ago, I was driving by this field and I saw a flash of red. Something was saying, *Just come out here,* and I did. This piece of pipestone has millions of years of weather on it. It's beautiful, the patina, the rippling on both sides. Some people say they feel vibrations coming out of certain rocks, and I always thought they were nuts in the head. But you run your hand over this baby, and there's something special comin' off it.

To you, things like this have memories, but to your kids, it might be just another piece of junk to get rid of. I have a little bit of sadness around that, but it's just like with your parents: Someday, when they pass, you'll have memories of them, then the next generation moves on and pretty soon your parents aren't even a memory, just something written on a tombstone.

~ **Vance Walgrave,** co-owner, Those Blasted Things rock and gift shop, Luverne, MN

"I WAS DRIVING BY THIS FIELD
AND I SAW A FLASH OF RED.
SOMETHING WAS SAYING,

JUST COME OUT HERE."

Texas COMMERCIAL DRIVER LICENSE

USA TX

DIRECTOR
4d CDL
4a Iss
3 DOB
1 BRAMER
2
8 AUSTIN TX 78745
12 Restrictions A
16 Hgt
5 DD

9 Class AM
4b Exp

9a End NONE
15 Sex F 18 Eyes

DONOR

"I became Arlo Guthrie's tour manager. And, yeah, I drove the bus."

I got my commercial driver's license when I was 21. I took the test in Lumberton, North Carolina, on a chicken farm, and I was the only girl in the class. It's just the hardest thing I've ever done in my life. Imagine backing up in an 80-foot-long vehicle that weighs 80,000 pounds. But I practiced and practiced in all kinds of situations, and I graduated number one. I beat all the boys.

I had a degree in music management and I'd been touring with indie musicians, and at some point I realized that if I had my CDL, I could be more valuable on tour. Later, I became Arlo Guthrie's tour manager, personal assistant, and, yeah, I drove the bus. It was Arlo who nicknamed me "Killer." He just loved that I was a 5-foot-4 lesbian with a high voice and a killer work ethic. Then, for a while, I transported the traveling Evel Knievel museum, and now I transport prototype trucks for equipment manufacturers, like Mack and Freightliner. I get to drive things before anyone else does.

I just turned 43, and I'm driving 500 miles a day, so that's like 182,000 miles per year, and I've been on the road for 22 years. The best part about the job is the characters you meet along the way. Not long ago, I met a mechanic named Tank who took me to play cowboy golf—you play through cow pastures and aim for an old coffee can—and a woman sitting at the Silver Dollar Saloon in Butte, Montana, who told me stories for hours.

You know, truck drivers have this stigma that you're a bottom-of-the-barrel worker. My family definitely didn't approve. But I'm super proud of my CDL; it's what's gotten me where I am. It's, like, the people I've met, the things I've seen—my life has been so odd, and I'm having such a ball.

~ Killer Bramer, professional driver, Austin, TX

When you play a flute in space, Ochoa told us, "You have to put your feet in foot loops or the force of the air you're blowing pushes you in the other direction."

You don't get to take very much on the Shuttle, so I was really happy that I was allowed to bring my flute. I starting playing when I was about 10, and I got this particular flute just before graduating high school. So it's been with me for a long time, through band, ensemble, symphony orchestra, and solo recitals.

Space is obviously a place where I never dreamed I'd get to play it—184 miles above the Earth. Being an astronaut is what I've dedicated my life to, but music has always been there for me. The opportunity to play this flute in space brought all the parts of my life together and that was incredibly special. I played a Mozart concerto; sometimes when I play it now, I think back on that day.

~ Ellen Ochoa, director, Johnson Space Center; first Hispanic woman to go to space; Houston, TX

"Space is a place where

I NEVER DREAMED
I'D GET TO PLAY IT."

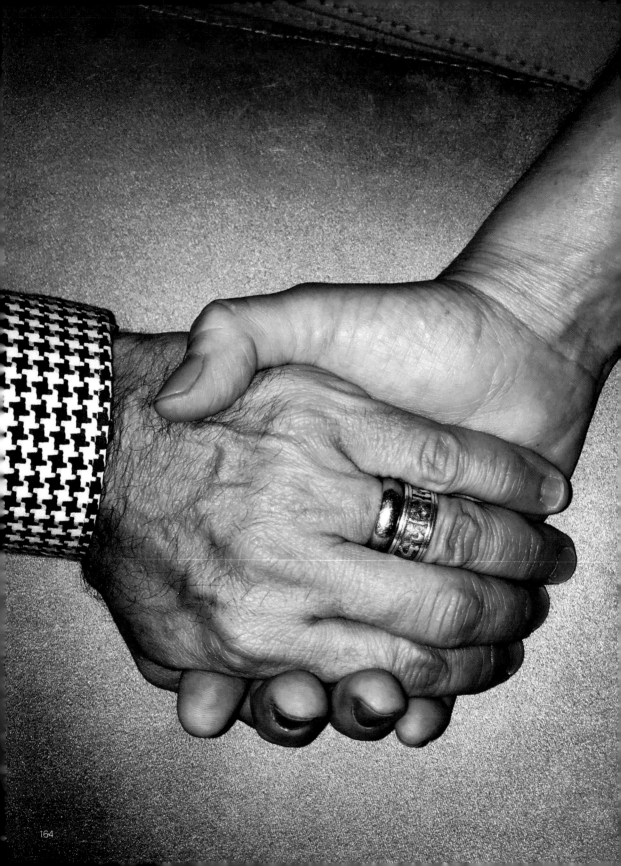

"THE RING IS THE TIE BETWEEN ME AND KATE AND SCOTT."

I was hit by a drunk driver when I was 12, and it changed the course of my life.

My family was on vacation in Atlanta—actually, we were just leaving an amusement park—when a car ran a red light and threw me into the intersection. This was during rush hour and two more cars hit me. My left leg was up by my head; I had a compound fracture of my femur. I remember my head being in my mother's lap, and she was brushing my hair back—this is absolutely a visual memory—and I asked her if I was going to die. They managed to save my leg but I spent about a year in a body cast, from armpit to toes, on one side. I missed all of eighth grade.

The driver was a former policeman and he was friends with the judge; he received a $500 fine. It was the injustice of that decision that got me interested in the law, and I eventually became a lawyer and moved to DC.

I met Kate through a mutual friend, and there was an immediate spark. She was just in town for a week, and on our first date we told each other our stories: She was 28 and a widow. She'd lost her husband to a drunk driver while he was riding his bike in Plano, Texas, where they'd lived. The driver was so drunk, he didn't know he'd hit Scott. And then there was the whole trauma of Scott not coming home from the ride and then Kate getting a visit from the police.

We probably did six months or a year of the relationship in that first week because of this shared experience. We understood each other, what we'd gone through. Fourteen months later, we were married.

This ring popped up sometime later, in a box of things she had, some memorabilia. When I saw it, I thought it might have belonged to her father. But it was actually Scott's wedding band. I instantly wanted to wear it, and I asked Kate if she would be okay with that. It fit me perfectly, and I've been wearing it next to my wedding band ever since.

I love our life, even the hard and painful pieces that have taken us here. And I love my wife. She wouldn't be who she is without Scott's influence. The ring to me is the tie between me and Kate and Scott. It's our intertwined lives and a history that will really never be untangled.

~ Greg Schaffer, vice president of Global IT and eCommerce Audit, Walmart, Bentonville, AR

"He never spoke about it, but I learned that he had taken wonderful pictures."

My grandfather—my *jiddu*—was a hardworking guy who dropped out of school to support the family. He never spoke about it, but I learned that he was a self-taught photographer and had taken wonderful pictures of his fellow soldiers in WWII and of a trip to Lebanon in the early '70s. Near the end of his life, he called me over and said, "I want to give this to you." It was a Kodak bellows camera that he'd bought during the Depression. I was studying photojournalism at the time, so that moment had a lot of emotion. It was my *jiddu* who brought me into the community and defined who I am as a Lebanese American. Without him, I wouldn't have the connection to my heritage and I wouldn't be doing what I do today.

~ **Devon M. Akmon,** director, Arab American National Museum, Dearborn, MI

"Such an act of bravery and desperation and hope"

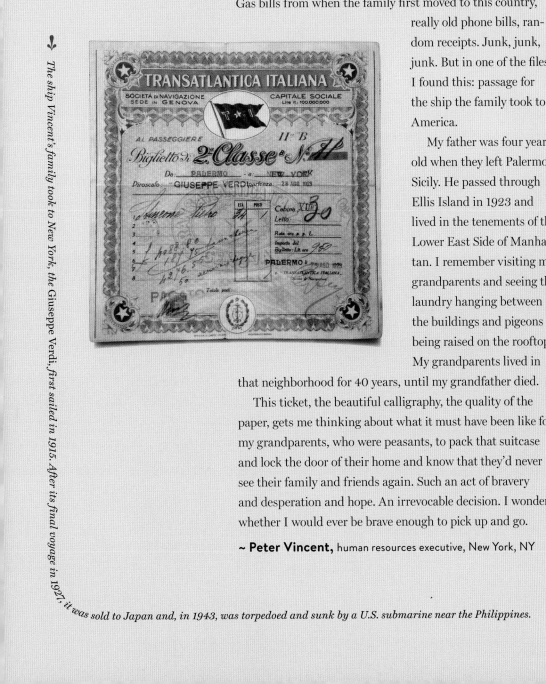

It must have been 20 or 30 years since my father and his brother had spoken, but after my father died, I wrote to Sal. He started sending me all kinds of junk from their childhood. Gas bills from when the family first moved to this country, really old phone bills, random receipts. Junk, junk, junk. But in one of the files I found this: passage for the ship the family took to America.

My father was four years old when they left Palermo, Sicily. He passed through Ellis Island in 1923 and lived in the tenements of the Lower East Side of Manhattan. I remember visiting my grandparents and seeing the laundry hanging between the buildings and pigeons being raised on the rooftops. My grandparents lived in that neighborhood for 40 years, until my grandfather died.

This ticket, the beautiful calligraphy, the quality of the paper, gets me thinking about what it must have been like for my grandparents, who were peasants, to pack that suitcase and lock the door of their home and know that they'd never see their family and friends again. Such an act of bravery and desperation and hope. An irrevocable decision. I wonder whether I would ever be brave enough to pick up and go.

~ Peter Vincent, human resources executive, New York, NY

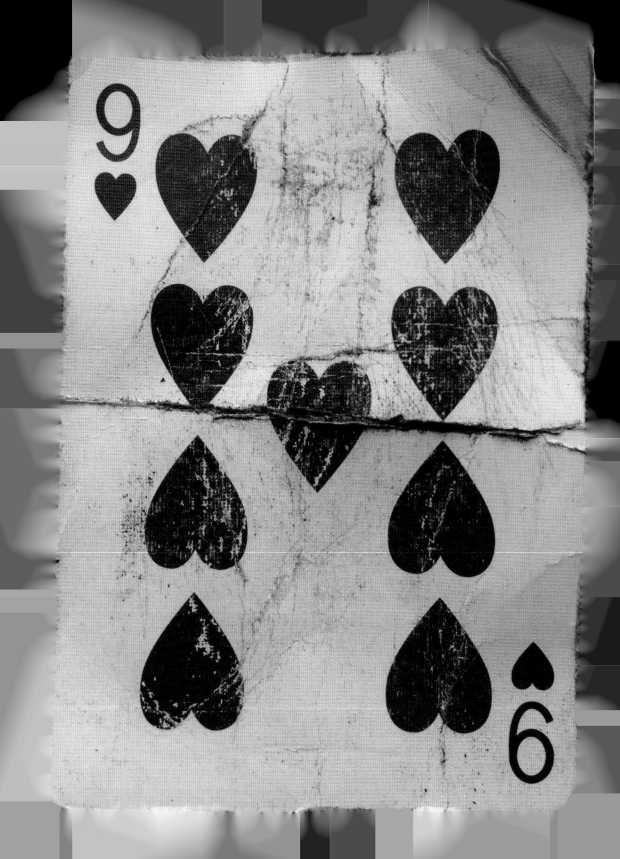

"IT WAS A HAIL MARY."

This nine has been riding in my wallet for the last three years and I don't see any reason at all to stop carrying it around. I drew it in a poker game to land the biggest pot of my life. I could have folded. Easily. It was a Hail Mary, but I went for it. It's worth reminding myself to sometimes take the big bets.

~ **Mark,** entrepreneur, Santa Monica, CA

Years ago, I picked
this up at a flea
market to give to
someone as a birth-
day present. But I
ended up keeping it.
I was living by
myself at the time—
it was my first real
apartment—and
I liked the lonely
soldier guy. It was
the only thing I had
on the mantelpiece
above a fireplace
that didn't work. I
somehow identified
with this singular
figure. I still do.

~ **Richard Baker,** creative
director, Brooklyn, NY

"AND THEN THERE'S MY
OCTOPUS GLASS"

As a winemaker, I deal with a lot of expert sommeliers and wine industry people. I attend dinners that can be extremely formal, where there's a specific glass for each varietal, and food is matched with the right wine. And then there's my octopus glass, which I picked up on a family trip to the Long Beach Aquarium. It reminds me that wine should be fun.

~ **Tondi Bolkan,** winemaker, Francis Ford Coppola Winery, Geyserville, CA

I'm passionate about technology, and the iPhone has opened up another world for me in terms of access, but this cane, with no components and nothing mechanical, has enriched my life in so many ways. I was probably four or five when a cane was first put in my hand, and I remember thinking it was a neat thing to carry around with me. When I was 16, I began using a guide dog, and over the years the cane has actually become a little more complicated for me. It's allowed me to experience the world, but it's also an object that causes people to see you differently and sometimes to assume that you need help, which can make you feel less independent. I still might use it to learn a particular route—where the bricks start or where two sidewalks meet—or just to have that tactile sense of where I am. This cane means a lot to me and it has its little place, right near my door.

~ **Katie Frederick,** digital accessibility specialist, the Ohio State University, Columbus, OH

I built this motorcycle with a tight group of friends when I was 17. I built it so I didn't have to run around the neighborhood being a drug dealer. I built it because it was time for me to fly.

It's a 1927 Indian Scout and there's all kinds of special things about it, like the throttle is on the left and the frame was given to me by a man who was born in 1927. That holds a lot of heart for me. The last person to rebuild the motor was George Yarocki, a special man in the motorcycle world, and he just passed away. I've been riding it for 27 years; I've got 12, 15 bikes, but this one sleeps in my bedroom.

It's the bike I ride on the Wall of Death, and I'd say I've done a million laps on it. For me, the Wall of Death breathes life: When I come off that wall and I'm able to see the look on people's faces and hear kids asking for my autograph, I realize that, yeah, this is my job, but I also have a chance to tell them that if you practice hard at anything, you'll be successful at it, and that being at a motorcycle show with your dad is what it's all about.

It's a miracle that I'm alive to be able to give a little testimony. I used to burn down the highway with the state troopers chasing after me. It's been seven years coming up out of the mire, three going on four being out of the state pen, and pushing almost seven years without a drink. That's been a really positive thing in my life, being clean and sober and having a clear mind. It's been one heckuva ride.

~ **Rhett Giordano,** motorcycle racer and stuntman, Columbia, SC

"THIS ONE

SLEEPS IN MY BEDROOM."

"Now I could stop holding back."

I was looking around in a high-end consignment shop for something to wear to an event, and I found this Chanel blazer. It's loud and beautifully hideous, and I owned nothing like it. Which is why I bought it. I didn't end up wearing it to the event, and it sat in my closet for two years.

As the 2016 presidential election approached, I discovered Pantsuit Nation and thousands and thousands of women online who were sharing their struggles and feeling undermined by men. I experienced an immediate sense of solidarity. They were saying exactly what I felt.

On Election Day, I was on the site reading posts by women talking about what they were going to wear to the polls. And in that instant, I knew: the blazer. I saw this as a symbolic moment, when I could wear something designed by Coco Chanel, this badass powerhouse of a woman, and support the first woman on a presidential ballot.

So I wore it and took a picture and posted it. I had always been a quiet, thoughtful listener and had never been vocal about women's rights, but now you knew *exactly* who I was voting for. I lost friends on Instagram and Facebook, but I didn't care at all. In a way, the blazer helped me realize how important it was for me to have a voice and not give a shit about how my opinion stacked up to other people. Now I could stop holding back. The blazer represents all of that. It represents me going forward.

~ Kelly Krause, conference programming manager, SXSW, Austin, TX

➤ *"The most courageous act is still to think for yourself. Aloud." ~ Coco Chanel*

I cherish this little button, even though for me it represents a failure. I had intended to spend my life in public service, so at the age of 30, I ran for City Council in Queens. This was 1971 and Queens was a rotten borough. I had a band of antiwar and pro-reform supporters but not a lot of money. My opposition had all the money they needed as well as voter fraud and judges on their side. This was my first taste of corruption, and, in fact, the person I ran against later went away twice on felony charges. Twenty-six political leaders in Queens eventually went to jail; it was quite a group. Anyway, I came up short.

I was a young man, newly married, we'd just had a child, and we were broke. I remember after the campaign was over with, our car was repossessed. It was embarrassing. I quickly started a business that helped companies like Marvel Comics figure out if they were being overcharged by their printers. From there, we went on to investigating businesses for investment banks and even investigating corrupt heads of state, like Ferdinand Marcos.

Fighting corruption, bossism, closed systems—that's my life's mission. That's what drives me. That's what's always driven me. And that's why I love the button.

~ Jules Kroll, chairman, K2 Intelligence, New York, NY

"This was my first taste of corruption."

"I *am* his wildest dreams."

My great-grandfather was born in Jamaica in the first generation after slavery was abolished there. He traveled across to Cuba as a young man to work in the sugarcane fields so he could save money for two things: a plot of land and a ring. He hadn't even met my great-grandmother yet; this was all in preparation for what was yet to come, for his children yet to come. That's what this ring represents to me; it holds the future, it holds possibility. Because that's what it held for him. To know that I *am* his wildest dreams fills me with pride.

~ Kamilah Forbes, executive producer, Apollo Theater, New York, NY

Before Forbes's husband proposed to her, he approached her mother and grandmother. They told him this

THE RINGS THAT GOT AWAY

My dad's aunt raised him, and I was super close to her when I was young. She was a schoolteacher, and I remember how when she found out I couldn't spell my middle name—Yevette—she wrote it on a little easel and had me copy it until I figured it out. After she passed of cancer, my dad had a ring made with a big *G* and *A* on top, for her name, Geneva Adams.

I loved that ring and I wore it all the time. I held it dear to my heart.

When I was a junior at Baylor, we went to the national championship in Denver—we were having a really great year, 40 and 0—and I left the ring in a drawer in the townhouse because I didn't want to lose it.

Well, we got robbed. They went and took everything, our CDs, Play-Station, even my clothes. But I only cared about losing the ring. I never like to wear jewelry anymore, and if I could find that ring I'd probably start crying.

~ **Brittney Griner,** center, Phoenix Mercury, WNBA, Phoenix, AZ

I'm not a collector of things, but I had a signet ring that was given to me by my father 30 or 40 years ago. It had the family crest on it and it had been *his* father's. I never wore the ring. I kept it in a safe for all that time. But two years ago, I was heading to Jamaica and I knew I was going to see my son; I thought to myself, *I'll offer it to him.* When I got there, I put it on. A few hours later I decided to go swimming, and I remember thinking, "I have to be really careful it doesn't come off." I dove in, and in 20 seconds— boom!—it was lost. I've tried every which way to find it. It's a sad and pitiful story: After all those years, I literally wore it for two hours.

~ **Chris Blackwell,** founder, Island Records, New York, NY, and Jamaica

story—which Forbes had never heard—and gave him the ring she now wears.

These spurs were Dad's. I grew
up ranching, and I learned
by watching him. He set the
bar high in life and work. I can
only hope to one day be half
the stockman he was. I guess
I'd like to fill the boots that
these spurs fit on.

~ **Tom Pepin,** rancher, Harding County, SD

"MY LIFE TOOK SOME PRETTY WIDE DETOURS."

One of my strongest early memories is of a great blue heron landing in my backyard, a sort of pterodactyl-like creature from the distant past. I recognized it because as a little girl, I wanted to be a wildlife biologist and my dad had this cloth-covered guide to North American birds that I used to flip through all the time.

When I was 9 or 10, I bought this great blue heron—it looks like wood but it's carved from animal bone—and gave it to my dad for Father's Day. When my parents split up and he moved out, he left it behind. I grabbed it and hid it because I knew my mother would get rid of everything that was his.

My life took some pretty wide detours after that—foster care, studying acting, then life in a noisy city—and for many years when I looked at this bird I felt a longing for another life, for what could have been. But around when I was 40, I started turning back toward my childhood love of nature. I moved from Boston to Washington State, and now I live in a valley next to two wild rivers where I see herons and eagles every day. When I look at this bird now, I think about the life I wanted to have and then coming full circle and starting to see it actualized.

~ **Jenn Dean,** grant-writing and fundraising consultant, Carnation, WA

"There was a pigeon skeleton, an old shoe, **and a trowel.**"

We were working on the oldest part of the cathedral and I was walking at the top of the ribs, up near the ceiling, when I caught a glimpse of something in one of the vaults. I had to shimmy 10 or 15 feet down to get to it. There was a pigeon skeleton, an old shoe, and a mason's bucket trowel. I left the pigeon and the shoe.

The trowel was rusty and the handle was rotten, but once I cleaned it up, the steel had an incredible patina from years of being dipped in sand and mortar. It's wonderfully balanced and broken in, and the steel has the nicest spring to it. The guy who used it was a righty, like me; you can tell because the left side is worn. I started using it.

Work began on the cathedral in 1907, and this trowel makes me think back on the generations of masons, stone carvers, and sculptors who worked on this building. I feel the connection. My dad was a mason and I was actually using one of his trowels when I found this. But this one is pretty special. This one has provenance. I had it with me on September 29, 1990, with President Bush looking on, as we finished the cathedral and I helped lay the final stone.

~ **Joe Alonso,** head stonemason, National Cathedral, Washington, DC

➥ *Bailey's family photos
are integral to his work.
His sculpture, painting, and
mixed media are included
in the collections of the
Metropolitan Museum of Art,
the Smithsonian American
Art Museum, the Nelson-Atkins
Museum, and on and on.*

"I was trying to figure out my direction and how to **move forward.**"

Right before my grandmother passed, we went to her house for Christmas. I was in art school then, maybe 19, 20 years old, and she lived in Palmyra, Virginia, way out in the country, and hadn't seen much of my work. At one point, she went to the back of the house and came out with the family photo album. It was thick and old and full of tintypes, probably from the late 1800s. She gave it to me.

It wasn't long before I started using the photographs in my work. These kinds of pictures usually end up in antique shops or are discarded or lost, so having them in a museum or gallery was my way of giving them a longer life than they would have had, of saving my family history. At the time my grandmother gave me the album, I was trying to figure out my direction and how to move forward, you know, what did I want to make? As a young artist, you're always looking for someone or something to influence you. And she was that. The photo album was that.

~ **Radcliffe Bailey,** artist, Atlanta, GA

I hit this ball a fuckin' mile. Just whomped it over the left fielder's head and we won the game. I've gone on to do a million cool things since then, but right there I was perfect.

~ **Randy,** financial planner, Baton Rouge, LA

"Every part of this paddle

tells a story."

This paddle was given to me in Mozambique by a local fisherman, an older gentleman with a weathered face who you could tell had spent his life on the ocean. He lives in one of the poorest areas of the world, where they depend on fishing for food. Foreign trawlers had cleaned out the local fisheries, and we'd been working for about 10 years to give local communities more control. Now they're catching larger fish and they're able to feed their families.

It's not the most elegant paddle I've seen, but every part of it tells a story. The handle is broken in half but instead of getting a new one, the fisherman nailed it together because deforestation has made wood so scarce. On one side of the blade, there's an etched set of lines. Like a checkerboard. He told me that during the years when the fisheries were cleaned out, the fishermen would pass the time by playing a board game on the blade. I keep the paddle by my desk. It reminds me of what's at stake if we don't care for the land and the ocean.

~ **Carter Roberts,** president and CEO, World Wildlife Fund, Chevy Chase, MD

**"I think about who
I was then and
who I am now."**

I keep this iPod in the glove compartment of my car. A lot of what's on it are playlists and photos from my first real relationship, my first true love. He and I bought an RV and took a six-week road trip from Seattle to Colorado, then through Texas, Tennessee, the Carolinas. I listen to the playlists when I'm alone and have a long drive; that's when I get sentimental—you know, when you want to wallow in your memories? I'll remember what part of the drive we were on when we first heard a particular song. That was 12 years ago. Now I see him every six months or so, but we're so different. I think about who I was then and who I am now. Was I okay living the rest of my life arguing? Would I be okay now with less passion but more stability? I've never backed up my iPod. There's part of me that feels like when it dies, it wants to be gone, that I should find new music, that it's time.

~ **Kaija Mistral Towner,** hair and makeup artist, Seattle, WA

"They were fantastic characters who lived off their wits."

Doc Stacher was a stone-cold certified gangster and a prince of a guy. He grew up with my father in Newark, where they gave him the name Doc because he always dressed in white. Doc's closest associate was Meyer Lansky, the big, big boss of the Jews. All those guys—Doc, Lansky, Abner "Longie" Zwillman—they were all uncles to me.

Now compared to Lansky, Doc was under the radar, but eventually he caught the attention of the Kennedy administration and they brought charges. They made a deal: no jail, but he had to leave the country. So Doc goes to Israel and sets himself up in the Presidential Suite of the old Sheraton, right on the Mediterranean. Doc was only allowed back in the U.S. once, for his sister Esther's funeral. They gave him a one-time passport.

For a while, I was putting bingo, slots, and other gambling machines in clubs, shoeshines, candy stores, and number holes—until the feds got me on illegal gambling and copyright infringement, and gave me a 19-month, tax-free vacation for it. But I loved those old-timers no matter what. They were my masters and teachers, these fantastic characters who lived off their wits. We had everything back then—parties, the Catskills, Florida. I have hundreds of pictures from that time on my wall—Jerry Catena, boss of the Genovese family; Milton "Tootsie Roll" Levy; Dustin Hoffman, researching a role by talking to me and some of the old-timers; my father and Tony Bennett; and Doc.

In 1986, Doc's nephew gave his old passport to me. He understood that of everyone in the Jewish underworld, I would appreciate it because I had a sense of history. "You deserve it," he says. For me, it symbolizes that fantastic world that I come from. We were so close in our world. Closer than blood.
~ **Myron "The Jew from Jersey" Sugerman,** retired gangster, Montclair, NJ

"MY DAD WAS

RECRUITED TO JOIN

THE MANHATTAN

PROJECT."

When my father was in his early 20s, he enlisted in the army. They gave him all sorts of aptitude tests and discovered he had incredibly strong mechanical ability. He was placed in technical training at Columbia University where he learned to fabricate scientific instrumentation from glass—which it turned out he had a real gift for. He was recruited to join the Manhattan Project and wound up in Oak Ridge, Tennessee, a top-secret location where they were working on refining uranium for the atomic bomb.

After the war, my dad went into business making highly specialized instrumentation for chemistry research—and he was able to buy a really nice house in Queens. I remember him drawing these incredibly complex machines, perfectly rendered systems, on napkins and then disappearing into his lab to bring them to life. Those napkin sketches are gone, and all I have of his work is one piece of glass—an osmometer, an instrument made of a series of glass tubes. This piece of glass represents everything I have in my life right now: When my father died, he left me the house in Queens. I eventually sold it and used the money to buy a 130-year-old, 15,000-square-foot dilapidated factory in Jim Thorpe, Pennsylvania. My wife and I converted it into an art hub with galleries, a visiting artist studio, a restaurant. We hold concerts, run workshops—people come from all over. Our home and the community we've created here, all of it exists because of what my father could do with glass.

~ **Victor Stabin,** painter and illustrator, Jim Thorpe, PA

"We're not permitted
to own anything."

It was 1959 and I was an artist visiting Rome, seeing the history. On Easter, I went to the vigil at St. Peter's. Somehow, I felt this force bringing me to the communion rail. That one communion changed my life: I was so filled with the experience that I knew I had to live in a community of perpetual adoration. That was April, and I entered the monastery in November that same year.

Our life is mainly one of prayer and of penance, a life of adoration and contemplation. We've taken a vow of poverty and a vow of chastity and obedience, and we're not really permitted to own anything. I actually do not have a desire to keep anything—except for a rosary and a few relics.

I'm fortunate to have a relic of St. Thomas the Apostle—I'm named after St. Thomas—and one of St. Francis and St. Clare. You see them and you're inspired to pray to them, to ask for special grace for everyone. You have a feeling that their spirit is there, that you have a part of them with you. On the other hand, you don't get too attached to them. A life is so much bigger.

~ Sister Mary Thomas Schiefen, Poor Clares of Perpetual Adoration, Cleveland, OH

"You can't really bring a
hammer on an
international flight."

What makes an object real to us? How does the brain respond to the real-world aspects of an object, to its texture, shape, and weight? These ideas have always interested me.

When I started studying visual perception, I realized that our knowledge is almost exclusively based on studies involving *images* of objects, as opposed to the things themselves. I wondered if the brain might respond in a fundamentally different way to actual 3-D objects. I used this duck in my very first experiment, and it's been with me all through my postdoctoral years and into my assistant professorship. For me, the duck represents continuing the legacy of my research and helping students develop their own ideas and academic lives.

There's also the fact that I speak at a lot of international conferences about my research, which often involves small, graspable objects like forks, pens, and hammers. But you can't really bring a hammer on an international flight, so I always pack this duck.

~ Jacqueline Snow, assistant professor, Cognitive and Brain Sciences and Integrative Neuroscience Programs, Department of Psychology, University of Nevada, Reno, NV

"I REALIZED I COULD EITHER BE AFRAID OR FIGHT—BUT NOT BOTH."

➥ *"I've always had comfort clothes, security clothes," Mckesson told us. "I had a jean*

My vest. My blue vest. I literally wear it every day. I wore it in Ferguson and in Baltimore. I wore it to the White House. I wore it when I met with Hillary, and Bernie, and Senator Warren. I keep getting it patched, I keep fixing it up. But I wear it *everywhere.*

It's become a thing, a way people identify me. Which is funny because the only reason I bought it—this was in 2009—is that I made a split-second decision to visit friends in New York City and I underestimated how cold it would be. So I borrowed clothes and a hat, but I needed a jacket. I went to Paragon Sports and bought the vest.

Why do I wear it? It's light and it's warm, and I just feel safe in it. Okay, that's totally irrational, but it's like a security blanket.

In the early days of the Ferguson protests, the police stayed near their cars. And then one night they didn't. They were moving into the streets. They boxed us in, and we started running. I was wearing shorts, and my iPhone cord was falling out of my pocket. At that time, we all kept our hands up—like, "hands up, don't shoot"—and I thought that if I reached for my cord, the police might think I was reaching for a weapon. It hit me that I might die for reaching for my iPhone cord. Right there, I realized I could either be afraid or fight—but not both. And I knew that I needed to do something about that fear. That's when I started wearing the vest all the time.

~ **DeRay Mckesson,** activist, organizer, and educator, Baltimore, MD

jacket in middle school with big pockets inside. I wore it every single day . . . until my grandmother threw it away."

"I thought I was supposed to grow up to do GIRLY THINGS."

I still remember the smell of the soldering wire that my dad and I used to assemble this transistor radio. I was 11 and struggling to understand my dad, since he didn't have a "normal" dad job, like construction or accounting. He was a "random access memory designer" and his technological world was a mystery to me. But he fixed TVs and radios at his workbench, and I was curious and good at taking things apart, and we starting doing it together. I remember feeling uneasy about that since I thought I was supposed to grow up to do girly things. I thought making the radio might turn me into more of a boy than a girl, and that scared me. All these years later, when I look at the radio, I think of the electronic components that eventually let me into my father's world. When I want to reconnect to that slow-motion time before life got even more complicated, I turn it on and listen.

~ Heidi Reed, creative services manager, global health nonprofit, Pawtucket, RI

➡ *Steve Jobs once said that building Heathkits as a child gave him "the sense that one could*

build the things that one saw around oneself in the universe. These things were not mysteries anymore."

"It's the most
violent thing
in my house."

Throughout my life, the match, this humble, overlooked object, has always amazed me. It's the most violent thing in my house, this little coffin sitting there in the drawer. It always makes me think: These little sticks with phosphorus and sulfur at the tip can light your stove and illuminate a celebration and also burn down a city. They're the symbol of everything luminous, and yet they bring us so close to danger. The self-effacing match lights, burns, and then dies a quiet death, reduced to ash, disappearing in its own use. But, for one flicker of a second, it reveals something primordial, something beyond any man-made object.

~ **Daniel Libeskind,** masterplan architect, World Trade Center, New York, NY

"I hear her voice
whenever I use them."

I remember my grandmother peering over her reading glasses, sewing outfits for my Barbie, then G.I. Joe, snipping a tiny sleeve with this pair of scissors. I hear her voice whenever I use them: *Having thick hair is a good thing when you get old*, as I trim my Middle Eastern eyebrows. *Just wear heels. And for God's sake, some lipstick*, as I cut the thread from a hemmed pair of slacks.

I wish I'd asked her where she got them. Did they first catch her eye in a Tehran shopkeeper's window? Did they travel with her to Delhi, L.A., San Francisco, all the places she passed through before settling in Florida? There are actually a lot of things I wish I'd asked her: How do I cook that pomegranate chicken dish? Did I make a mistake by dropping out of law school? Did she regret remaining faithful to an unfaithful husband?

~ **Debbie Danielpour,** professor and writer, Boston, MA

I wear a small Slinky on my middle finger. It reminds me to observe the world playfully, as a child does, and to experience something with all of my senses before I define it.

~ **Elliot V. Kotek,** social-impact filmmaker, Los Angeles, CA

"I WAS KIND OF SURPRISED
AT STILL BEING ALIVE."

I have an old Red Sox cap. By old, I mean from back when I was living in Cambridge, going to grad school, and working on my very first book. It's blue and red and filthy. The dirtiest thing you've ever seen. I can't even wear it anymore.

But it reminds me of a time in my life, a time of energy and possibilities, when things hadn't narrowed. I didn't know if I would be a successful writer or even a writer at all. It was only two or three months after I'd returned from Vietnam, and I was still shaky from the horror of being in combat all the time. I was in an academic program at Harvard that would have led to a job as a teacher or in the State Department, and I would spend from midnight to 2 a.m. working on my book *If I Die in a Combat Zone*. It wasn't even a book then —I didn't think of it as a book for the first year and a half. It was just memories.

During those days, the hat was my way of not being a regular citizen of America, a way of remembering the world I grew up in, a small turkey town of 9,000 people in southern Minnesota. I wore the hat to class and on weekends, all the time. I was 23 or 24, and I was kind of surprised at still being alive. I had expected I'd die over there. So when I look at the hat, it's reminiscent of the feelings I had then, feelings of rebirth, *I'm not dead* and *What am I going to do with this life that I didn't expect to have?*

~ **Tim O'Brien,** author, *The Things They Carried* and *Going After Cacciato*; Austin, TX

"Back then, my grandfather's side of the board was all grooved out and mine was flat."

I've cut over two million steaks on this board. When I was six or seven, I'd stand right next to my grandfather, cutting alongside him in the restaurant. He started me off trimming fat and he'd watch me with an eye like a laser. He was my idol and all I wanted was to please him. Back then, his side of the board was all grooved out and mine was flat.

In grade school, I got out at noon on Mondays and it was the best time of the week because my grandfather would take me with him to Sioux City and we'd go right to the kill floor and pick out the beef to bring back to Archie's. My grandfather had an eye for beef and he was a legend in the stockyards. When I was in fourth or fifth grade, he went into the hospital to have tests run. We lost him the next day, and it was earth-shattering for me, for all of us.

My grandfather had opened Archie's in 1949. For a long time, the family had nothing. We had nothing but we had everything, if you know what I mean. I became the principal meat cutter when I was 14, and now I own the restaurant. My sister Lorrie works the front of the house and my mom, who ran Archie's from '73 until she retired in '95, still stops by. When anything major comes up, well, nothing happens until I've talked to her. Today we do about 500 meals a day, and in 2015 we won a James Beard Award. Not a day goes by that I

don't wish Grandpa were here to see this.

We're a steakhouse and everything starts at the board. The thing is, every piece of beef presents a different shape and size; no two pieces are the same. You take what it gives you, you put it on the board, and you shape it into the cuts you need. I still spend four to five hours a day at the board, and you know what? Cutting is the most peaceful time for me.

This still feels like my grandfather's restaurant, but some years ago I looked at the board and realized my groove was as deep as his.

~ **Bob Rand,** owner, Archie's Waeside restaurant, Le Mars, IA

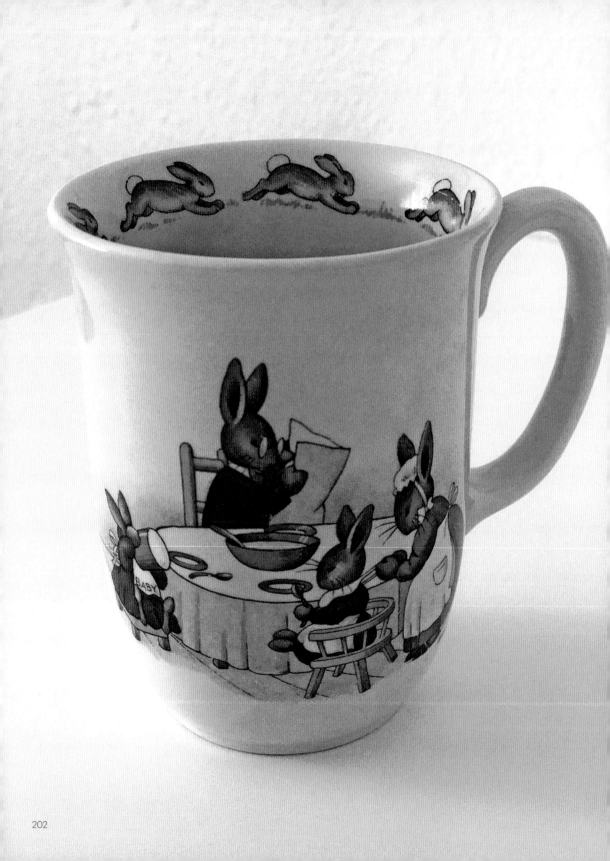

"IT'S THE ONE THING
I'D ALWAYS
WANTED."

Before my mother had her first schizophrenic breakdown, I remember our family being happy. My mother made a big deal out of holidays, especially the decorations, and we always had dinner together. A lot of good memories.

And then it all disappeared.

I was eight or nine when my mom got sick, and a lot of her illness was expressed as a weird jealousy of me. She would do things like give my brothers birthday parties but not me. Around this time, my father stopped coming home for dinner. My mother would prepare dinner, then we'd wait for him while she paced around, crying.

I remember she had a china chest, and I'd stand there looking at this cup with this happy bunny family on it. Every so often I'd say, "Can I touch it?" and she'd take it out and let me hold it for a little while. Then she'd put it back. Even then, I guess I could feel that something was slipping away.

After college, I was getting ready to go overseas and she said, "Here, you can have this." She gave it to me and said, "Go off and live your life."

I took it with me to Turkey, where I taught English, and later to Kenya. The cup to me represented my freedom, and it really launched me into my sort of peripatetic life—and my ability to keep moving when things fell apart. When my marriages ended, it's the one thing I held on to. I've lived in at least 20 different places, and it's been all over the world with me, this piece of china. It's a sweet little cup, but it holds a lot: It's both a reminder of what was lost and a symbol of my independence from my mom and from her illness. It's the only thing she's ever given me—and it's the one thing I'd always wanted.

~ **Jenifer Fox,** founding head, the Delta School, Wilson, AR

One of my rods is just
kind of a little time capsule
for me. I can hold it and
remember standing in a
particular spot in a river
on a particular day. Some-
times, if it's quiet in my
head, I can feel my uncle's
hand over mine, teaching
me how to cast.

~ **Scott Tarrant,** professional fly-fishing guide,
Tarryall Mountains, CO

Acknowledgments

CREATING A BOOK LIKE THIS—in which hundreds of folks agree to talk to a couple of strangers about their most precious object—requires the help of many, many people. Some of them are name-checked here, but to countless others, like the editor of the newspaper in Red Cloud, Nebraska, (pop. 948) who set his deadline work aside to give us directions to his favorite restaurant, we are also grateful.

Without the people who offered their stories, carefully photographed their objects, and shared sometimes deeply personal memories with us, this book wouldn't exist. To you, we offer our endless and heartfelt appreciation.

Thanks to Richard Baker, beyond-brilliant creative director and true friend, who designed this book. (You can find his object on page 170.)

Thanks to Betsy Towner Levine who re-sourcefully, tirelessly connected us to so many remarkable people, and to the go-go-go Kacie Jo Marta, who wore two hats: Fixer and Photographer Extraordinaire.

Thanks also to Kim Cross, Ben Cosgrove, Gabrielle Birenbaum, Chris Napolitano, Jason Kersten, Val Taliman, Jonathan Rosoff, Rich Behar, Mitch Rosenwasser, Dawnie Walton, Cheryl Strayed, Brooks Kraft, Bill Robinson, Kris Connell, Kelly Krause, Sid Evans, Vivian Trachinski, Jon Gluck, Eric Bromberg, Alan Paul, Ann Moore, Steve Debro, Matthew Snyder, Liz Arnold, Alexander Honnet, Dawn Bridges, Gayle Osterberg, Lauren Glover, Lise Hilboldt, you might be quizzed on these names later, Ted Moncreiff, Fran Hauser, Olivia Ridout, Mark Jacobson, Amanda de Beaufort, Stephen Reel, Anya Strzemien, Colin Sterling, Little Milo, Matt Lee, Sue Hovey, Dara Hogan, Tobin Levy, Luther Jaffe, Keith Arnold, Kristin Ohlson, David Browne, Becca Sandowsky, Ethan Curtis, Marci Benson, Peter Cohen, Vanessa Bajaio, Andrew Crotto, Wayne Grant, come on now and stay with us here, Kris Beyer Jones, Brian Bollinger, Stacie Stukin, Stephen R. Hyer, Rhonda Pelikan, Alexandra Neuburger, Holly A. Johnson, Julia Novakowski, are you reading this just to see your own name?, Alex Abramovich, Barnaby Harris, Jim McNamara, Natalie Boten, Andy Blau, Virginia "Ginger" Gough, and Jane Rowe. Thanks to those who wished to remain anonymous (you know who you are) and to the Innocence Project, Friends of Refugees, Studio Libeskind, NASA, the *Pittsburgh Post-Gazette*, Good Egg Branding, Marvel Comics, and the Willa Cather Foundation. Special thanks to the Ford Foundation OC and to Getty Images.

Thanks to the great Neil Leifer, who so graciously shared both his story and his photo. Thanks to Fran Hamburg for her wisdom, to Bernard Ohanian and Mark Jannot for their silver pencils, to Scott Raab, Ryan D'Agostino, and Fred Klemmer for their big hearts.

Thanks to those who contributed stories that appear on our Facebook page (facebook.com/groups/WhatWeKeep/) and on Instagram (≠WhatWeKeep), including Frosty McNeill, Amy Gotliffe, Clay Mazing, Liz Rasser, Pam Laker, Basha Blankee, Lois Newell, Peter Grubb, and many others.

And, as with everything, eternal thanks to Laney and Lynne, to Harvey, Robin, Bernard, Dean, Wendy, Lisa, Maya, Laila, and Mickey, who is still undefeated.

A gigantic thank-you to Running Press, especially to our terrific editor, Jennifer Kasius, and publisher, Kristin Kiser, both of whom believed in this book from Day One, as well as to designer Susan Van Horn.

Finally, thanks to Brian DeFiore, agent, friend, truth teller, and guiding light all wrapped up in a bow.

Photography Credits

A thousand thank-yous to the professional photographers who brought out the beautiful qualities in these often-humble objects. We deeply appreciate your time and talents.

Ryan Jenks (*p. 8*)

Justin Walker (*p. 34*)

Aldo Carrera (*p. 61*)
Wall art by Julianne Rose

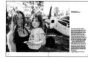

Renan Ozturk (*p. 76*)

Peter Braverman
(*painted rock, p. 108*)

Lane Collins
Photography (*p. 12*)

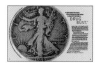

Wayne Grant (*p. 38*)

Wiyanna Oakley (*p. 62*)

Kacie Jo Marta (*p. 86*)

Aaron Tredwell (*p. 111*)

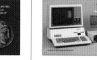

Susana Millman
Photography (*p. 17*)

Gates Archive (*p. 40*)

Chris Bott (*p. 66*)

Denise Prince
(*wig, p. 93*)

Dr. Michael Lano (*p. 113*)

Greg Badnerosky (*p. 19*)

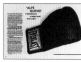

Neil Leifer (*p. 44*)

Kory Klem
(*carved cane, p. 68*)

Asher Weintraub
(*baseball card, p. 95*)

Justin Conway
(*shark's tooth, p. 114*)

Tony Vu (*p. 24*)

Tony Stamolis (*p. 46*)

Rhonda Pelikan (*p. 70*)

Jinele New & Jina
Girolamo, Mimi J's
Photography (*p. 98-99*)

Justin Walker
(*Sarah Gray Miller, p. 124*)

Amanda Avutu (*p. 26*)

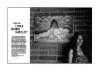

Eric Scott Dickson
(*p. 50*)

Glenn James /
Getty Images (*p. 73*)

Patrick A. Ziegler
(*projector, p. 106*)

Paul J. Richards /
Getty Images
(*Bill Clinton, p. 125*)

»

Martin Reuben (p. 129)

Anton Brkic (p. 156)

Chelone Ione Towner (iPod, p. 186)

Jenni Ochsner (p. 200)

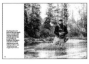
Justin Walker (p. 204)

Peter Braverman (Amy Webb, p. 130)

Courtesy of NASA (Ellen Ochoa, p. 163)

Jon A. Holderer (p. 188)

IF YOU'VE MADE IT THIS FAR …

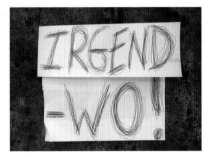

Mary Beth Shaddix (seeds, p. 138)

Devon M. Akmon (camera, p. 166)

Garie Waltzer (religious relic, p. 190)

BILL'S OBJECT: I've held on to this sign since 1986. *Irgendwo* means "anywhere" in German, and Fred and I used this to hitchhike out of East Germany … back when it didn't matter where we ended up or when we got there.

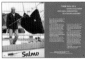

Kristen Angelo (p. 140)

Kacie Jo Marta (p. 172)

Bryan Sutter (p. 192)

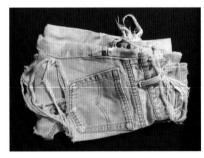

Gabriela Hasbun (Anarghya Vardhana, p. 148)

Celine Grouard (p. 176)

Heidi Reed (p. 194)

AND NAOMI'S OBJECT: These were my favorite jeans in high school, but at some point I lost them (don't ask) for two years. When they turned up, I was so happy that even after I'd worn them to shreds, I couldn't let them go. I keep them as a reminder not to dwell too much on the things I've lost but rather to celebrate the amazing things, both material and not, I've found in my life.

Jon McNally (Tony La Russa, p. 152)

Kacie Jo Marta (p. 178–79)

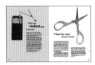
Studio Libeskind (matches, p. 196)

Darren S. Higgins (paddle, p. 185)

Miriam Berkley (Tim O'Brien, p. 199)

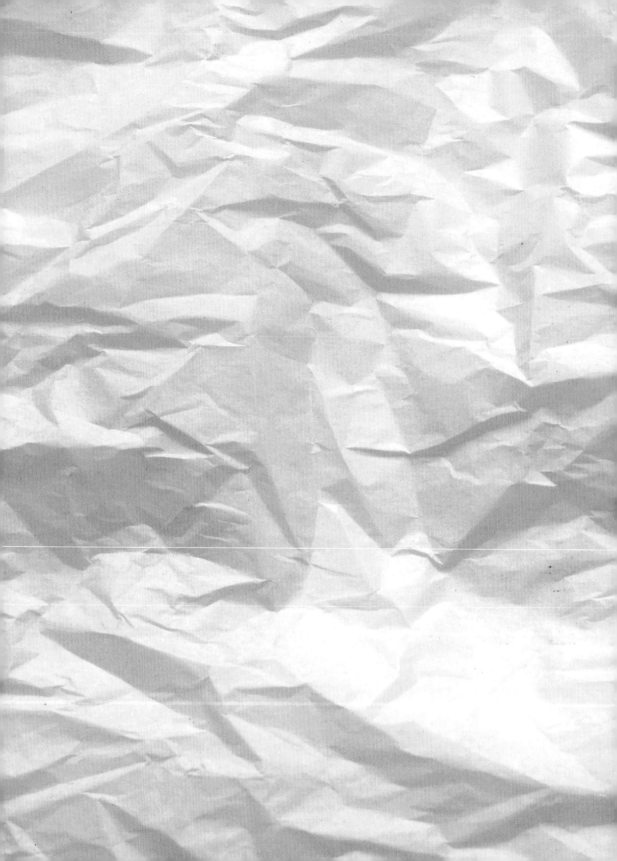